CANNERY ROW

The History of John Steinbeck's Old Ocean View Avenue

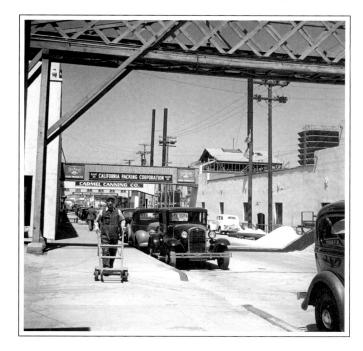

By Michael Kenneth Hemp

With Photographs from the
Pat Hathaway Historical Photo Collection
of California Views

Published by
The History Company
P.O. Box 222612
Carmel, CA 93922
www.thehistorycompany.com

THE HISTORY COMPANY

P.O. Box 222612
Carmel, CA 93922
USA
www.thehistorycompany.com

Printed in the United States of America

LIBRARY OF CONGRESS CATALOGING-IN-PUBLICATION DATA

Hemp, Michael Kenneth, 1942-
 Cannery Row: the history of old ocean view avenue

 Bibliography: p.
 Includes index.
 1. Cannery Row (Monterey, Calif.) 2. Monterey (Calif.)-History
 3. Steinbeck, John, 1902-1968-Homes and haunts-California-Monterey
I. Title
F869.M7H35 1986 979.4'76 86-32023

ISBN 0-941425-01-0

Cover design by Bridges Design Associates, Los Angeles
Publication design by The History Company

All the Photography in this book is available from

THE PAT HATHAWAY HISTORICAL PHOTO COLLECTION OF CALIFORNIA VIEWS

Mr. Pat Hathaway, Photo Archivist
469 Pacific Street
Monterey, CA 93940
(831) 373-3811
www.caviews.com

There are over 80,000 images in this historical photo archive including Monterey, Cannery Row, Carmel, Pacific Grove, Pebble Beach, Carmel Valley, Point Lobos, Big Sur, Salinas, the San Francisco earthquake and fire and all of the California Missions. Please see our web site for a more complete listing.

The Pat Hathaway Collection catalog numbers are indicated in brackets under each photo. Inquiries for photo reproductions or enlargements should be accompanied by the catalog number and a brief description and page number.

DEDICATION

THIS BOOK IS DEDICATED TO THE CANNERY ROW "ALUMNI"— THE MEN AND WOMEN WHO WORKED ITS CANNERIES AND THE MEN WHO BRAVED THE PACIFIC FOR ITS SILVER HARVEST.

Cover Photo: George Seideneck [72-012-053]
Cannery Row's enclosed conveyor cross-overs, 1945, with cannery worker, Hank Damewood.

SPECIAL THANKS

My Special Thanks go to the following people, without whom this book would not have been possible:

Charles Nonella, Frank Wright, Pat Hathaway, Horace "Sparky" Enea, Skipper Tony Berry, Tom Mangelsdorf, William B. Brown, Ed Ricketts, Jr., Fred Strong, Joanna Livesay, Thom Steinbeck, Jackson Benson, Will Shaw and The Thomas Doud Sr. and Anita M. Doud Fund of the Community Foundation for Monterey County, The Cannery Row Foundation, Skipper Salvatore Enea, Skipper Horace Balbo, Betty Hoag McGlynn, Mrs. Wesley Dodge, Skipper James Davi, Frank and Grace Bergara, Al and Esther Campoy, Dorothy Wheeler, Beth Robinson, Eldon Dedini, Tom Weber, Antonette Villines, Ray "Spats" Lucido, Robert V. Enea, Ted Melicia, Frank Tanaka, John Gota, Seizo Kodani, Francisco "Paco" Ferro, Maury Cooper, Bernard Jaksha, Frank Crispo, Daryl Stokes, John Stidham, Kalisa Moore, Dick O'Kane, Michael Maiorana, Anna Nowak and the Paquin Family, Anne-Marie Colendich, David Hemp, Sally Hanhy, Robert Edison, Bob Lippi, Herb and Robbie Behrens, Neal and Bettina Hotelling, Bill Johnk, Dennis Copeland, Sandy Lydon, Tim Thomas, Jake Stock, Mike Marotta, Katie Roger, Eric Enno Tamm, Larry Tsuneo Oda, Steve Eddy, James Bridges, and Ted Balestreri...and all the colleagues, cannery workers, skippers and fishermen, laborers and residents of the Old Row who have assisted this research.

I owe very special thanks to my wife, Terri Adrienne Wolfson, for her tireless support, patience and perseverance as an innocent casualty of my historical and artistic crucible.

CHARLIE NONELLA

In 1983, Charlie Nonella stepped out of the crowd at the Great Cannery Row Reunion and said, "You should talk to me." We talked almost daily for the next four years. Charlie Nonella had not only been a cannery worker with a bad reputation on old Ocean View Avenue, but he also happened to be the best friend and constant companion of another cannery worker, Harold Otis Bicknell, otherwise known in the canneries and around Monterey by his nickname, "Gabe."

John Steinbeck wrote to his editor at Viking Press, Pat Covici, that Gabe was his model for Mack, of "Mack and the boys" in his 1945 *Cannery Row*. Gabe was, indeed, the leader of an alcoholic group of roughnecks on Cannery Row that lived and drank and often worked together in the sardine factories of the Old Row. They lived in just about every flophouse in the Cannery Row district, including one called the Palace.

Charlie claimed to be the best "can catcher" on the Row--filling cases with sardine cans from a chute in the warehouse at Hovden's. I heard his claim grudgingly confirmed by others who also cited his well-earned reputation for drinking and fighting. Gabe was the kind of mechanic that machines just seemed to run better around. He could fix anything, a valuable talent in the canneries of Ocean View Avenue which were often maintained with a minimum of investment. Gabe and Charlie had an interesting operating plan. They never worked for a cannery a few days and then got drunk and fired. They worked for weeks, sometime months at a time, before allowing their drinking to cost them their jobs. When they went back looking for work, as highly qualified, hard working cannery laborers, they got hired again.

Charlie was in a sanitarium with tuberculosis when Gabe died in a house fire in 1954. He stopped drinking, "cold turkey," in 1960 and saved his sight and his life. He smoked like a chimney and was never without a thermos of horrid black coffee. But his mind was like a camera. He could accuately recall details of his years on the Row: names, dates, people, events, work in the canneries. He was even a bouncer in one of the Row's whorehouses. Charlie Nonella shot a string of continuity, perspective and accuracy through my research I could never have achieved without him.

Charlie, like Gabe, was an accomplished specimen collector for Ed Ricketts and made several, rather routine, frog collecting trips to Carmel Valley, as reported in *Cannery Row*. I still miss him and thank him often for sharing his invaluble knowledge and memories of his life on Ocean View Avenue.

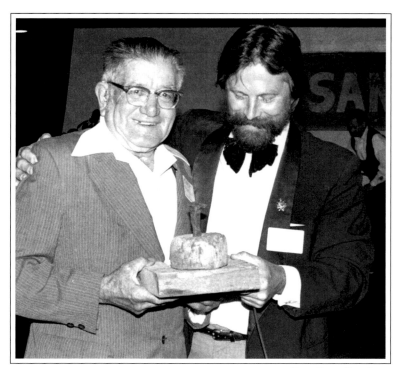

Ray Santella photo

Charlie Nonella receiving the Cannery Row Foundation's award for Cannery Worker of the Year at the Great Cannery Row Reunion of 1984. The award, presented by Michael Hemp, is a plank from the San Xavier Packing Co. (its cross-over sign in the background), a cork float from a purse-seine net, and a spike from the Southern Pacific Rail Road tracks pulled up on Cannery Row in 1984.

AUTHOR'S NOTES

Two of Cannery Row's most notable personalities have inspired the concept and design of this book: John Steinbeck and his close friend and mentor, Edward F. Ricketts. John Steinbeck's *Cannery Row* is a concise and easily read account of life on old Ocean View Avenue in the late 1930's, focusing on the adventures of his friend "Doc" (Ed Ricketts) and the misadventures of one of the most colorful casts of characters in American literature. John's interest and concern for the human touch in his fiction left little room, however, for facts that did not serve his nostalgic imagery.

Marine biologist Ed Ricketts loved "true things" and in the 1920s and 1930s he pursued his controversial approach to the study of marine biology with an awareness of how important context is in the discovery, explanation and understanding of physical, biological phenomena. His pioneering study of the inter-relationship of the organisms in the tide pools of the inter-tidal zone, the specialty at which he became a pioneering expert, provided the model for approaching all subjects. His *Between Pacific Tides*, published in 1940 by Stanford University Press, established him as a leader in modern marine biology.

CANNERY ROW The History of John Steinbeck's Old Ocean View Avenue is therefore concise, human and graphic, as John would like it. It is also as precise as current available research can make it. Its scope is intentionally broad enough to include the context of Monterey history necessary for an understanding and appreciation of the time and place the world has come to know as Cannery Row. I think that Ed Ricketts would further appreciate its utility in that this book—with its photography from the Pat Hathaway Historical Photo Collection and the detailed map-guide to old Ocean View Avenue—will prove especially useful to those with the opportunity to seek Cannery Row's history and the romantic nostalgia of its Steinbeck legacy in person.

Cannery Row would certainly have an historical identity of its own on the dubious merits of the ecological and economic disaster resulting from the collapse of the sardine fishery and the major Monterey industry it supported. Unfortunately, Cannery Row's unlearned ecological-economic lesson still haunts the world's oceans and collapsing fisheries today. But the men and women of the 1930s and 1940s that became subjects of John Steinbeck's *Cannery Row* have provided a nostalgic focal point for the whole of Monterey's canning history. The literary success of *Cannery Row* has elevated the street to world fame through John's wry and compassionate accounts of it, drawn largely from direct observation and participation in the decade of the thirties.

A primary objective of this book is to provide a vision of The Row as it was, from which unfolds both its emerging but little known "human history" and a vivid background for John Steinbeck's fiction. The map-guide and its indexed historical and Steinbeck landmarks serves to prepare or supplement the reading of the following books relating to Cannery Row by John Steinbeck:

Cannery Row, 1945
Sweet Thursday, the sequel to *Cannery Row*, 1954
Log From the Sea of Cortez, 1951 -- containing the "About Ed Ricketts" preface to the restructured 1941 publication of *Sea of Cortez*, co-authored by John Steinbeck and Edward F. Ricketts.

With or without such preparation, however, this presentation of Monterey's fishing and canning history provides a vivid perspective designed to enhance your appreciation and enjoyment of Cannery Row, particularly as less and less remains of the Old Row. With this book and the magic of your imagination you are invited to adventure into Cannery Row. It will never be again as it was, but the future will somehow always hold its ghost.

--MICHAEL HEMP

ABOUT THE PHOTOGRAPHY

It is important to note that photos selected for this book have been used as close to full-frame as possible, with cropping kept to a minimum. Due to the age and condition of some photos, variation in their clarity and contrast is unavoidable. Digital restoration has been employed, when necessary, to preserve the integrity of the original images. In some cases, photos chosen for this publication are not only the best available, but the *only* images available.

TABLE OF CONTENTS

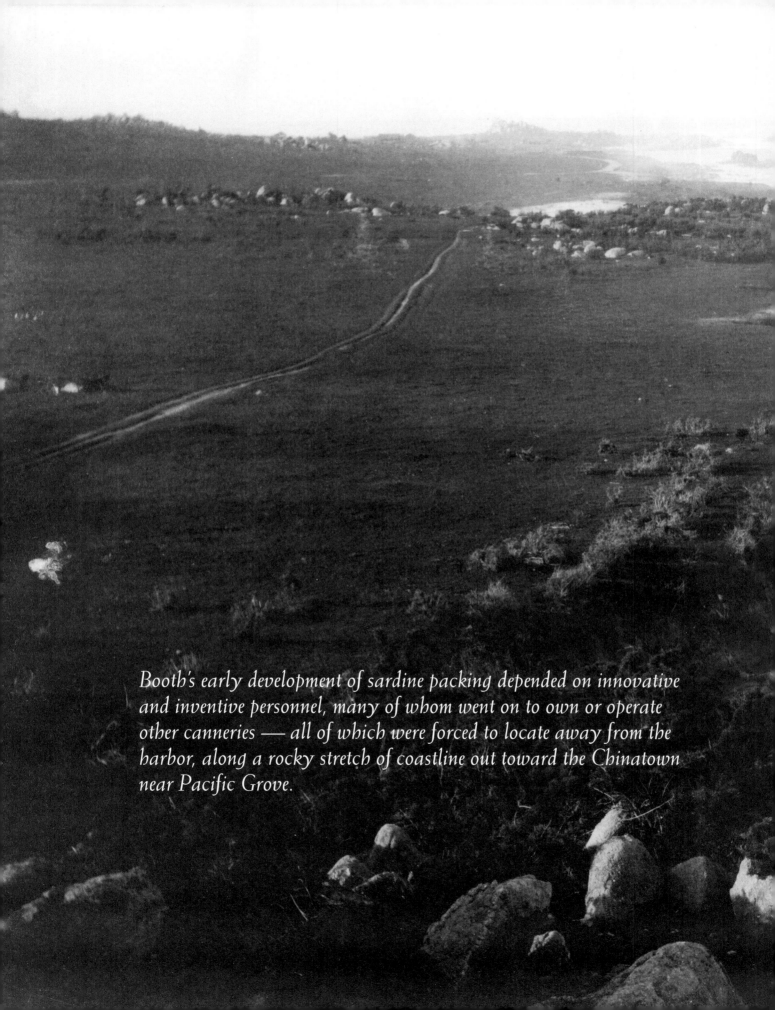

Booth's early development of sardine packing depended on innovative and inventive personnel, many of whom went on to own or operate other canneries — all of which were forced to locate away from the harbor, along a rocky stretch of coastline out toward the Chinatown near Pacific Grove.

The vacant coast south of Monterey on a road that would first host a soletary, elegant estate on this beach--which was eventually engulfed by a canyon of tin and timber sardine factories in the growth of the canning industry. Monterey's early wharf can be seen at the far left of this photo. I. W. Taber [83-003-01]

INTRODUCTION

Cannery Row's origins are a mixture of the rocky Monterey coastline and the toil and industry of the Orient. A Chinese fishing village, from which "China Point" derives its name, was established in the early 1850s and was devastated by fire in 1906.

Monterey's first major canning operation had begun next to Fisherman's Wharf when F. E. Booth's sardine canning experiment was matched with the skill of Sicilian fishermen and "lampara" fishing techniques. Booth's early development of sardine packing depended on innovative and inventive personnel, many of whom went on to own or operate other canneries — all of which were forced to locate away from the harbor, along a rocky stretch of coastline out toward the Chinatown near Pacific Grove.

The rutty, unpaved coastal road from Monterey to Pacific Grove grew to host the sardine factories that for half a century would dominate Monterey history and commerce. In 1902, Japanese venture pioneer Otosaburo Noda and Harry Malpas of San Francisco founded the first canning operation on Ocean View Avenue. In 1958 the street was re-named "Cannery Row" in honor of a writer who few regarded seriously when he had frequented it: John Steinbeck.

The intervening years are an epic tale of the lives, labor and fortunes at stake on Ocean View Avenue in the plunder of a seemingly inexhaustible natural resource — sardines.

Two World Wars, Prohibition and the Great Depression imprinted their marks on this famous street and its "Alumni." Fate's greatest imprint was cast with the disappearance of the sardines in the late 1940s. Depletion of the fishery, currents and pollution in the food chain have all been blamed for the demise of this once major industry and the street that supported it.

Edward F. Ricketts' famous comment, "They're all in cans" is an admitted oversimplification. Of course, he and other authorities on the fishery knew only too well the other answer, with roots even deeper in the canning process: two thirds of Monterey's sardines never made it into cans at all. They left town on the Southern Pacific rails as 100 lb. sacks of fish meal and as sardine oil. The reduction process, which turned the silver tide into sardine by-products, was far more profitable than canning for consumption, which required a much larger labor force and sold in far less profitable markets, usually overseas against nationally subsidized industries.

By the end of the forties, decades of warnings and urgent appeals for conservation had been ignored, ridiculed and discredited. Wartime patriotic fervor had also done little to encourage either conservation or attention to what scientists like Ed Ricketts knew only too well: Cannery Row was about to commit suicide.

The sardines virtually vanished by the early fifties. The last sardine catch was packed in 1964, with the last operating cannery, the Hovden Food Products Corporation — now the Monterey Bay Aquarium — closing its doors forever in 1973, canning squid.

The ecological disaster was, of course, mirrored by pain and human suffering as Monterey's major commercial resource mysteriously disappeared, leaving the once thriving fishing and canning industry to die on its waterfront in a ghostly gray demise. There was a time, however, when the inhabitants of this coast were far less vulnerable and dependent on the commercial bounty from the sea. And that is where this story of Cannery Row really begins…

FIRST INHABITANTS

It may have been the place the tribes called "Tamokt," the grassy hill overlooking the rocky hook at the south end of the long beach. To the north was the slough country, now known as Elkhorn, which provided fish, waterfowl and game for their diet, as its river wandered in wide marshes to the sea. These gentle, primitive natives were scattered in small groups along the shore and throughout the coastal and inland valleys. Their nomadic food-gathering and hunting took them wherever the seasonal foraging, game and weather provided them refuge and provision.

It is likely that from this spot the Indians witnessed Captain Juan Cabrillo's passing in November 1542, unable to anchor due to a severe storm. The expedition of Sebastian Viscaino, which anchored in the bay on December 5, 1602, was to claim this land for Spain--to include its "Costanoan" subjects.

Seasonal movements, acorn gathering, hunting and shellfish collecting continued uninterrupted until the Spanish came again in 1770, this time bringing Father Serra by sea, to meet Gaspar de Portola's overland detachment that had marched north from San Diego. The meeting point of these two expeditions was where the small creek ran into the bay, below the Costanoan knoll. This time the white men stayed and forever changed the fate of Monterey Bay's hapless original inhabitants. It also signaled the end of man's use of the bounty of this sea for his subsistence. The new lords of this coast were to set in motion the commercial use of its resources, a concept alien to the Rumsen and Eselen except for the shiny shells they traded to inland tribes.

In the century to follow, these passive "savages" were evangelized, exploited, dispersed, decimated by white men's diseases and racially absorbed into the Spanish and Mexican populations. Their vantage point above the bay had, however, quickly become the site of the conquistador's "presidio."

A VIEW FROM THE PRESIDIO

In the years since Serra's landing, the knoll that was once the sight of the Costanoan "rancheria" was to witness the establishment of Monterey as the Spanish capital of Alta California and the construction of "El Castillo," a fort at its crest with a view to the sea and the sprawling cluster of early structures on its shoreline.

In November 1818, three years before Mexican independence, the fort and harbor were brought under siege by the Argentine privateer Hippolite Bouchard. The fort's cannons accounted well for themselves, seriously damaging one of Bouchard's ships in a rare ship vs. shore-battery artillery duel, before depleting their ammunition. The town was looted and burned before Bouchard's ships set sail, the fortress having ultimately failed its protective purpose.

New England whaling ships, bound to and from ports like Lahaina, Maui, were a common sight at anchor in Monterey to replenish their provisions. The Alta California coastline was also familiar with Russian otter hunters, employing Aleuts with sealskin boats, who were joined by Spanish and American hunters to bring this widely pursued Pacific Coast species to near extinction, ironically about the time Charles Darwin was penning "Origin of Species."

On July 7, 1846, Commodore John Drake Sloat brought California under the flag of the United States when his forces put ashore to hoist the American flag at the Custom House. The Americans immediately set out to construct their own defenses on the knoll, known as Fort Mervine. Then came the gold rush to the Sierras which nearly shut Monterey down, even closing the fort in 1852. Reactivated briefly during the Civil War, it remained unused from 1865 to 1902.

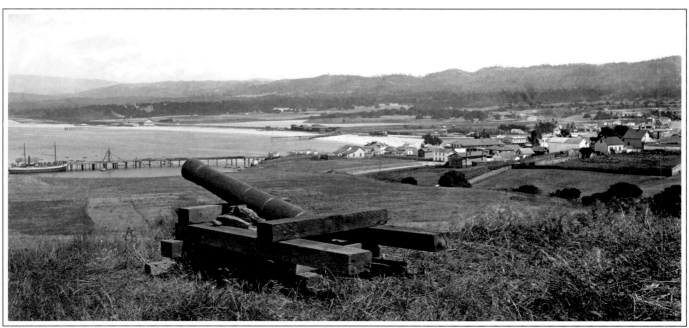

The distant Hotel Del Monte, its beachside bath house, Monterey's train depot, and the Pacific Coast Steamship Co. pier share the view from the former Costanoan knoll, and its El Castillo successor.

C. W. J. Johnson photo, early 1880's. [96-050-010]

THE POINT PINOS LIGHTHOUSE

The first navigation aids for west coast shipping were approved by Congress in 1850 which allocated funds for the construction of a series of eight lighthouses on the Pacific Coast—one located at Point Pinos, now Pacific Grove. The completed lighthouse cast its beacon for the first time on February 1, 1855, its lard oil light source replaced by kerosene in 1880, and by electricity in 1915.

Its first light keeper, Charles Layton, was killed in its first year of operation while on a posse in pursuit of Anastacio Garcia, one of the Central Coast's most notorious outlaws. Two of its light keepers have been women: Layton's widow, Charlotte, and Mrs. Emily A. Fish, 1893.

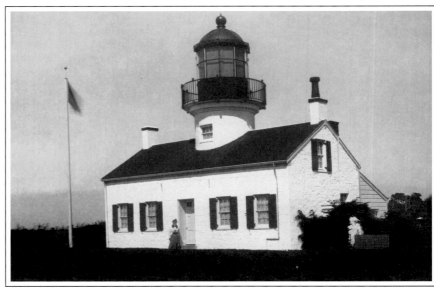

This beacon is now a Pacific Grove landmark, open for tours, and is the longest continuously operating lighthouse on the West Coast. Only San Francisco's Alcatraz light is older, but has not operated continuously. C. K. Tuttle [72-008-072]

PACIFIC GROVE

In 1875, a year after the arrival of rail service to the Monterey Peninsula, Reverend J.W. Ross formed the Pacific Grove Retreat Association, establishing a Methodist Episcopal Retreat in the wooded slopes above Point Pinos. Originally a summer tent camp, in 1889 its permanent residents incorporated Pacific Grove, complete with a curfew law and a fence that surrounded the entire settlement. Its gate was locked each night until Judge Langford, a prominent attorney, tired of the long walk for its key and chopped it down. It was never replaced.

The growth of the town soon made it an adversary of the continued Chinese occupation at China Point. In addition to the repulsive smell of drying fish and squid from the settlement, the righteous Christians of Pacific Grove became increasingly agitated over "heathen" Chinese religious ceremonies and unorthodox customs--such as the smoking of opium. Additionally, the Southern Pacific's acquisition of huge tracts of Monterey, Pacific Grove and Carmel Bay real estate included prime shoreline property envisioned for development--which included China Point. Bolstered by resentment and public opinion against the Chinese, in 1905 its Pacific Improvement Company ordered them off the site which they had been leasing since the 1850's.

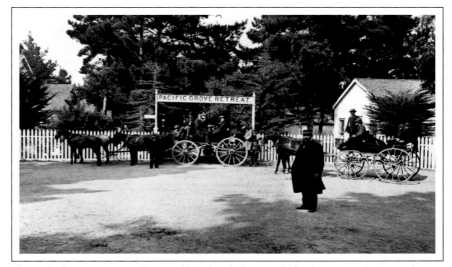

The Methodist summer tent cabins established with the arrival of rail service to the Peninsula soon gave way to a real town in the piney woods above Point Pinos. This photo is the town gate at Lighthouse Avenue and Grand Avenue. C. W. J. Johnson photo, early 1880s. [78-06-1]

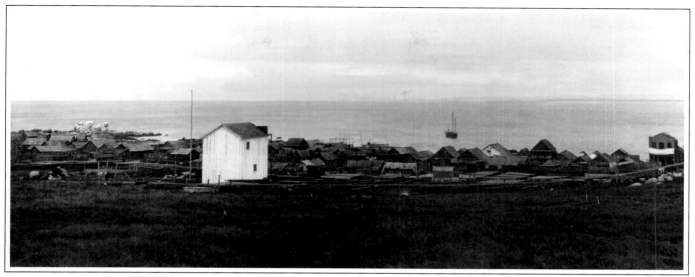

An early photograph records the Chinese settlement, its Joss House, and a junk anchored offshore. The odor from drying fish and squid was not a problem in the initial isolation of their settlement.

C. K. Tuttle [72-17-130]

Few peoples on earth use more of everything they catch, grow or process than do the Chinese; virtually nothing is wasted. So it was that when the first Chinese settled in the Monterey Bay area—in the cove at Point Lobos about 1851—they must have rejoiced at the variety and bounty offered to their talents as experienced fishermen.

Sandy Lydon's brilliant work on the Chinese of the Monterey Bay region, "Chinese Gold," is quick to point out that the Chinese settlements at Point Lobos, "China Point" (near Cannery Row), and Pescadero (Stillwater Cove) were populated by fishing families, often having arrived directly by junk from China. Unlike other early groups immigrating to the Monterey Bay, the Chinese came as whole families and took up fishing for their own subsistence, and for drying and shipment to other Chinese enclaves in America or export to China.

Monterey's fishing industry was established by the industrious Chinese who brought with them the technique of preserving their catch by drying it for shipment, an important element in the development of this major industry made possible by Monterey's dependably dry summer months. Not since the Costanoans had anyone used the total environmental resources so thoroughly, but unfortunately the efficiency with which they did so raised both concern and an element of envy among their many critics. With a purported $200,000 annual business at the turn of the century, the Chinese became the target for more than simple racial intolerance; their diversity and adaptation to the marine resources unexploited by Japanese and European immigrants led the more resourceful of those groups into direct competition with them.

The growth of Monterey's Chinese community in the late 1880s was paralleled by the influx of immigrants, most notably the Japanese, who entered fishing as a commercial activity. Early struggles for primacy on the fishing grounds left the Chinese to adjust to the rapid success of Japanese and European nationalities using the railhead to San Francisco to market "fresh" fish from their operations near the Customs House.

Restrictive legislation and regulation of Chinese fishing and processing techniques, and rising anti-Chinese sentiment, pressured the adaptive Orientals into a commercial species not in conflict with their rapidly entrenched fishing competition: squid. It was not a commodity of concern to European immigrant fishing groups and had the advantage of being conducted at night, when their fishing operations did not conflict with their rival's use of the bay. Pacific Grove's "Feast of Lanterns" is an ironic tribute to the torches and pitchwood fires used from the Chinese sampans to attract the curious squid to their waiting seines.

Exclusionary legislation heavily restricting Chinese immigration, prohibiting naturalization, ownership of land, testimony against whites, and access to public education, provided the back-drop against which local forces were being brought to bear: they were no longer welcome on China Point.

On the evening of May 16, 1906, the Chinatown where Pacific Grove borders New Monterey, was engulfed in flames that destroyed nearly the entire shanty-like settlement—itself hosting refugees from the April 18th San Francisco earthquake and fire. This pyre signalled the end of the Chinese fishing industry. Within a year its undisbursed inhabitants negotiated for and relocated to a new and much smaller settlement on McAbee Beach on Ocean View Avenue, near the center of what was to become "Cannery Row."

One of the few structures to survive the fire at China Point was the Joss House, or shrine. Perhaps only Trinity County's Weaverville Joss House rivals it in significance. Unfortunately, unlike its Weaverville counterpart--part of a railroad and mining Chinese presence--it did not achieve preservation as an historical monument. After the fire, it was moved to McAbee Beach where it remained until construction of the Monterey Canning Company in 1918. In March, 1942, it burned and was torn down on a Wave Street lot shared with a triplex for cannery workers, known by its inhabitants and neighbors as the "Palace Flophouse."

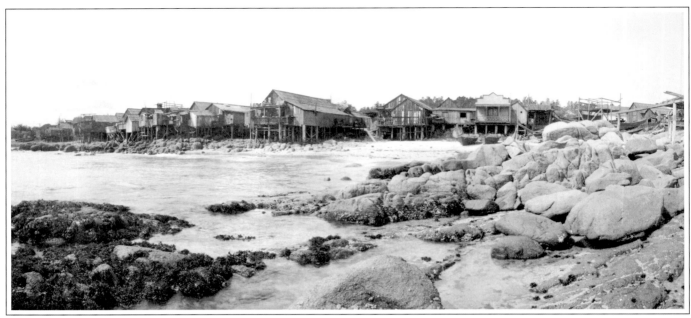

Monterey's coastal Chinese settlement was built right out to the water's edge, with direct access to the sheltered beach from which they launched their fishing boats. Fish were routinely dried on racks and lines within the village. It was large-scale use of the fields around the village to dry catches--particularly squid-- that drew objections to its smell from the ever encroaching cities of Pacific Grove and Monterey. Dan Freeman [73-035-03]

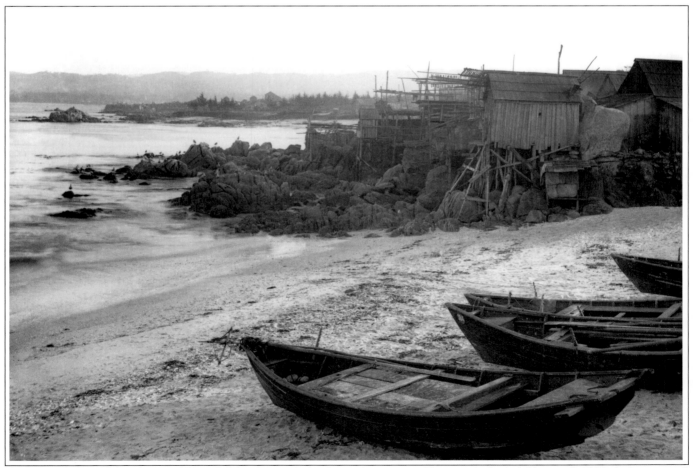

Flat-bottomed Chinese fishing boats could be pulled directly onto the beach, an advantage over feluccas and other keeled boats. C. K. Tuttle [72-08-132]

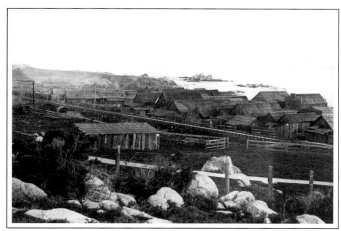

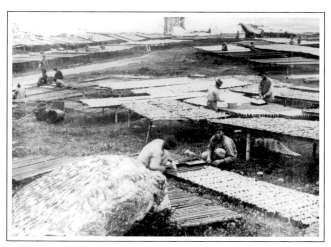

In 1889, the village was bisected by the track-bed of the Southern Pacific rail line to Pacific Grove. The division by the rail line did act as a fire break in the 1906 fire--the largest of three that struck the village since its establishment in the 1950s--and the last the Chinese would suffer. They were evicted after the fire. [80-07-1]

In the early isolation of the settlement, the odor of drying squid was not a problem--but would become one with the growth of Pacific Grove.
C. E. Watkins photo, 1883. [78-50-01]

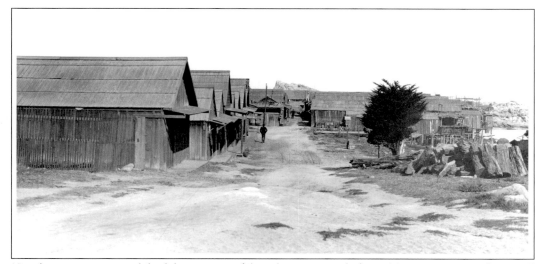

Note the granite point rising behind the main street of the settlement prior to the fire on May 16, 1906. [78-37-1]

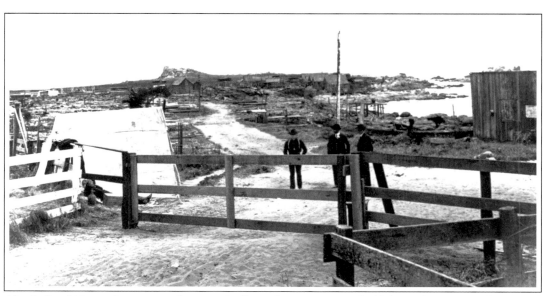

After the fire of May 16th, 1906, guards prevent the Chinese from returning to rebuild their settlement. [81-62-14]

WHAT A DIFFERENCE A TRAIN MAKES

The original trackway laid the nearly twenty miles between Salinas and Monterey in 1874, built largely by Chinese labor, was a "Granger's" challenge to the rail freight monopoly of the "Big Four"—Crocker, Stanford, Huntington and Hopkins. It was a narrow-gauge system connecting the Salinas wheat and agricultural markets to a rail pier in Monterey for shipment by sea. It also enabled the growing Monterey fishing industry to connect to major markets for its "fresh" fish up the line and in San Francisco. The Italian and Portuguese operators in Monterey did not ice or eviscerate (gut) the catch for shipment; the waste in spoiled fish kept the prices up.

Although the Monterey & Salinas Valley Railroad failed within five years - primarily due to winter bridge failures over the Salinas River - it demonstrated the market it could serve and its valuable access to the scenic Monterey Peninsula, which was quickly targeted for development as a resort destination.

When Southern Pacific bought the bankrupt railroad at auction, it matched the acquisition with a purchase of 7,000 acres of prime land on the peninsula from David Jacks, to complement and support Crocker's dream of constructing "the most elegant seaside establishment in the world." The doorway to the Monterey Bay area had been opened to tourism and large scale land development.

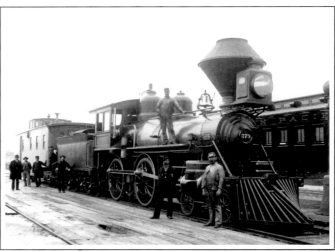

The iron horses of Southern Pacific brought the wealthy to the Hotel Del Monte and immigrants to the Monterey fishing industry, which prospered with a rail connection to San Francisco. C. K. Tuttle [72-08-54]

"THE QUEEN OF AMERICAN WATERING PLACES"

The magnificent Hotel Del Monte was constructed in less than half a year and opened its doors on June 3, 1880 to throngs of prominent and wealthy patrons from around the world. They were fetched by carriage from the hotel's own "Del Monte Station" on the new Southern Pacific line completed from the main line at Castroville. Its over 160 acres boasted exotic gardens, a lake, four heated swimming pools, a polo field, amusements and accommodations fit for royalty.

Perhaps its most unusual entertainment was the "seventeen-mile drive" through the crumbling adobes of Monterey, past the curious Chinatown to the Pacific Grove gate, and on to the "pebbled beach" on Carmel Bay. The original drive passed through the Chinese fishing settlement at Pescadero, where Jung San Choy and his family set up one of Monterey's first souvenir stands in 1881, selling abalone shells and other curios to the more adventur-

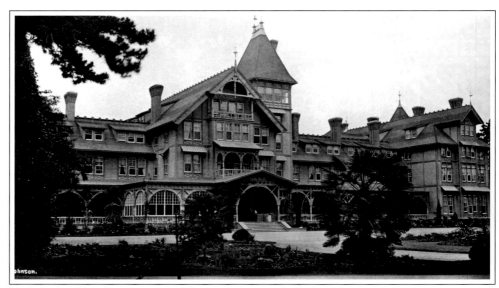

The hub of wealth and social activity of the Monterey Peninsula, the lavish hotel was to have a major impact on the economics of tourism and residential elegance. C. W. J. Johnson photo, circa 1880. [79-106-8]

ous of the grand hotel's carriage trade. The rustic log Del Monte Lodge began as a rest stop and place to eat while horses were watered or changed for the return trip to the hotel. Occasonal side-tours took in Carmel or the Mission on the way back over the Carmel hill to Monterey.

The lavish hotel was destroyed by fire on Aptirl 1st, 1887, and rebuilt from its original plans. Its Lodge at Pebble Beach on Carmel Bay was lost to fire in 1917 and reopened with adjoining lodging in 1919— the same year its golf course opened on the plateaus above Pebble Beach, a panorama which no longer included the Chinese.

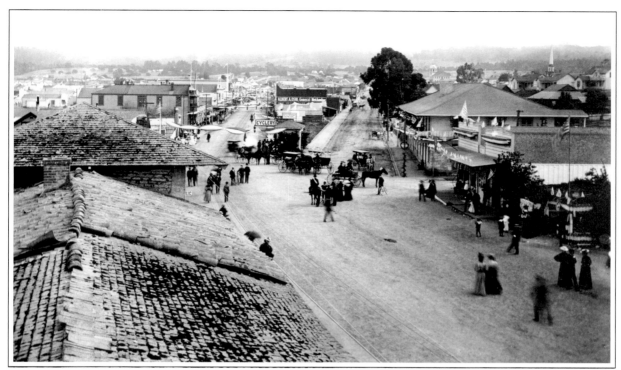

The Seventeen-Mile Drive passed through old Monterey, as seen in this view from the roof of the Custom House looking up Alvarado Street and Calle Principal, in this photo by C. W. J. Johnson, 1893. The two-story adobe Pacific Building at the right survives. [78-36-01]

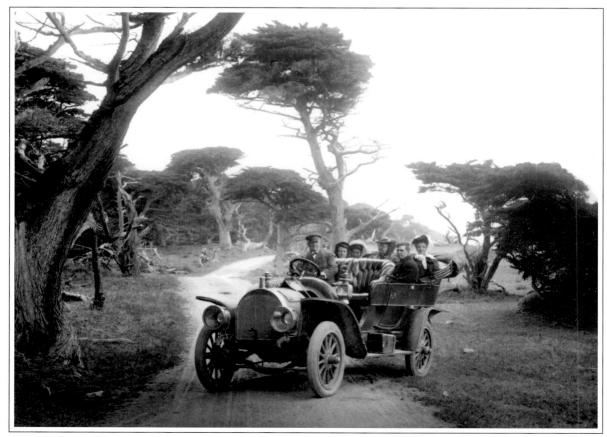

The world-famous "Seventeen-Mile Drive" circa 1910, when horse drawn carriages had been replaced by automobiles like the touring car seen in this photo taken near Cypress Point, not far from the early Lodge at Pebble Beach on Carmel Bay. C. K. Tuttle [72-08-45]

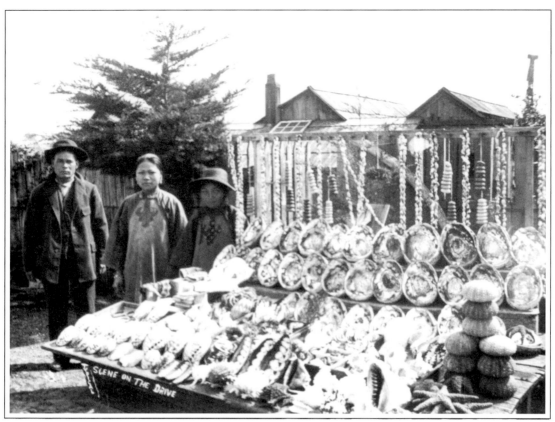

A souvenir stand--one of Monterey's earliest--was set up by Jung San Choy and his family beside their house on the Seventeen Mile Drive, on the shoreline above what is now Stillwater Cove. *Joseph K. Oliver photo [78-041-02]*

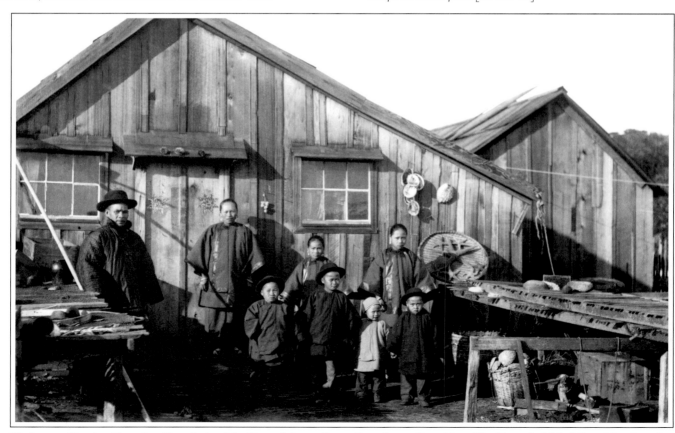

The home and family of Jung San Choy, leader of the Chinese fishing village at Pescadero on Carmel Bay. The Chinese had fished Carmel Bay from their earlier settlement at Point Lobos since 1851. *C. K. Tuttle [72-17-84]*

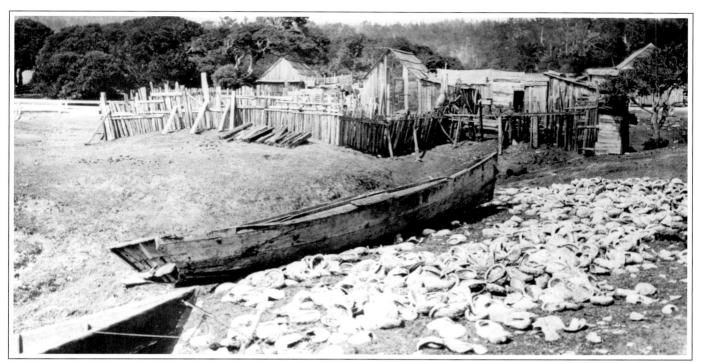

Another portion of the Pescadero Chinese fishing village from an 1880s photograph of what is now the Beach and Tennis Club of the Lodge at Pebble Beach. Joseph K. Oliver photo. [71-18-3]

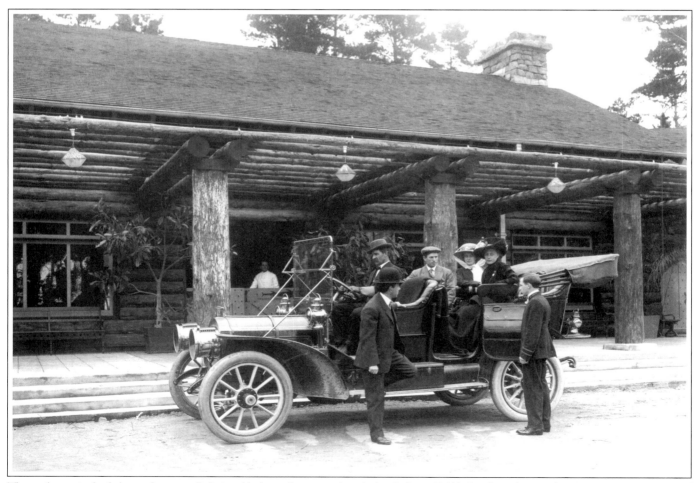

The gentleman in the derby in this 1911 R.J. Arnold photo of an arrival at the log Lodge at Pebble Beach is photographer Dan Freeman. Auto travel greatly facilitated access to the shores of Carmel Bay from Monterey and the Hotel Del Monte. [82-29-11]

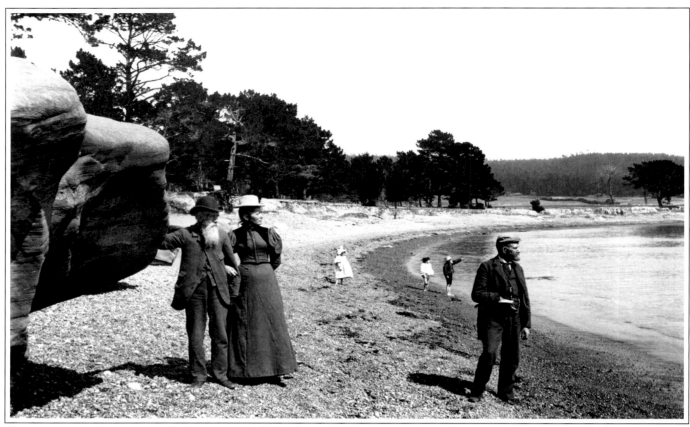

The graphic origin of a name: the pebbled beach on Carmel Bay. The 17-Mile Drive continued along the plateaus above the beaches nearly to Carmel before climbing the hilly return trip to the Hotel Del Monte.
 C. K. Tuttle [72-17-70]

Early Carmel, developed by L. Frank Devendorf and Frank Powers, was a curiosity worth a side trip from the Seventeen Mile Drive. By 1905 Carmel sported the chimneyed Pine Inn, as seen in this E. A. Cohen photo. *[77-03-0198]*

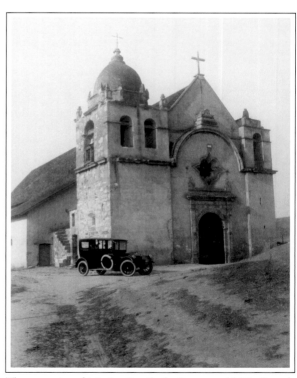

The restoration of Mission San Carlos Borromeo del Rio Carmelo began with an 1883 donation by Mrs. Leland Stanford. Lewis Josselyn captures the restoration progress and a Pierce-Arrow in this 1919 photo. *[71-01-0CM]*

Point Piños

Lovers Point

China Point

Pacific Grove

New Monterey

Cannery Row

Point Joe

Fisherman's Wharf

Seaside

Monterey

Hotel Del Monte

Cypress Point

Del Monte Forest

Mendocino

Sacramento

Lodge at Pebble Beach

San Francisco

Monterey

Moro Bay

Carmel

Carmel Bay

Santa Barbara

Los Angeles

Point Lobos

San Dieigo

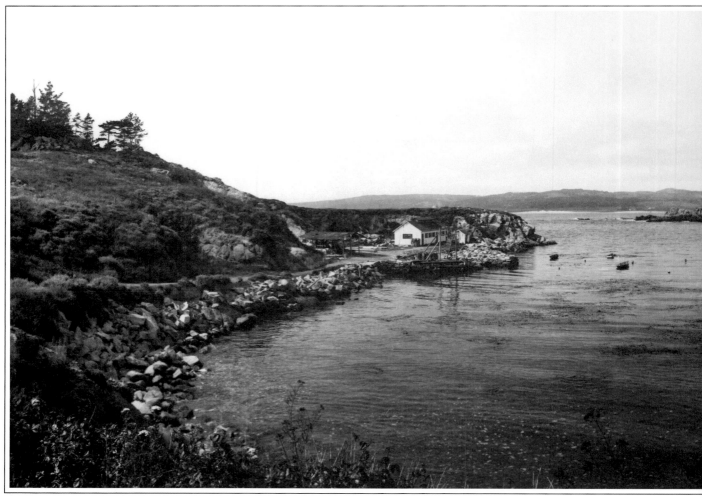

The sheltered cove, first settled by Chinese, used briefly by the shore-whaling Portuguese, became a major Japanese abalone diving and canning operation.

ABALONE AND THE JAPANESE

Japanese immigrants arriving in the early 1890s were predominantly farmers and part-time fishermen. It was pionoeer labor contractor and businessman Otosaburo Noda who reported back to Japan of the coast's plentiful abalone, particularly in the Carmel Bay area. The Japanese government sent Gennosuke Kodani, a marine biologist with extensive experience in hard hat diving technology—credentials that would establish the Monterey abalone industry—to confirm Noda's reports. Arriving in 1896, he completed a reconnaissance of the coast for the ideal location, which he found at Point Lobos—along with its owner A.M. Allan, who became a partner in the venture.

Abalone diving began with "free diving" without insulated suits or helmets, but the Pacific's frigid temperatures at Monterey quickly demanded the introduction of Japanese hard-hat divers, a first for this technology on the Central Coast.

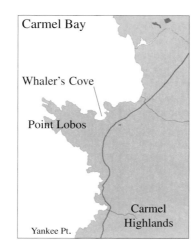

Kodani drew his divers from the Chiba Prefecture, near Tokyo, an area suffering ecomically and eager to employ its expert hard-hat divers in the new American venture.

Canning of cubed and minced abalone for export, supplemented by fishing for salmon and sardines for delivery to Monterey's developing canneries, soon established a solid Japanese presence in the new canning industry on the Cental Coast. Along with it came the prejudicial treatment and regulation so familiar to the Chinese before them.

The Japanese led the way for American hard-hat diving development on the coast, an indispensable asset in an industry that depended into the 1930s on off-shore cables for unloading fishing boats by steel buckets, and new, submerged pipleines from floating fish hoppers to each of its canneries.

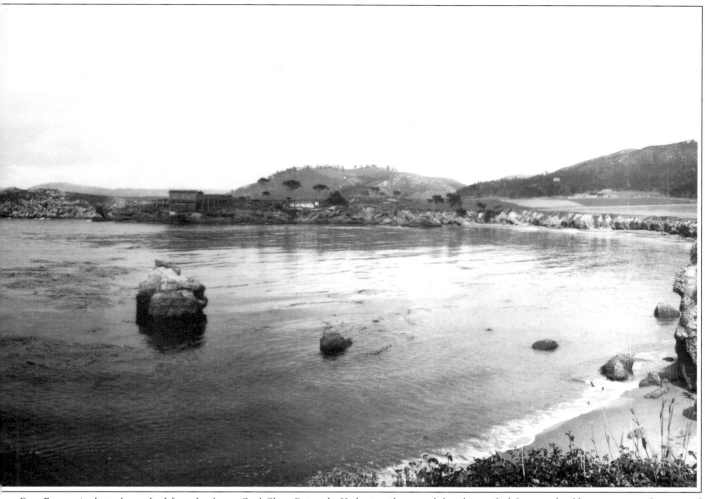

Dan Freeman's photo shows the defunct bunker at Coal Chute Point, the Kodani residence, and the whitewashed Japanese bunkhouse, 1905. [73-35-02]

Japanese cannery labor, specializing in the cutting operation, also became a major factor in the economic life of Cannery Row.

At its height, Point Lobos diving boats numbered up to eighteen—each with a crew of four—some operating as far south as Moro Bay. For a time the flagship of this Point Lobos flotilla was the "Ocean Queen," a sizeable rumrunner's boat abandoned in hot pursuit at the cove and later bought at auction from the government during Prohibition.

Prior to 1941, most of the fish processors and fish markets on Monterey's Fisherman's Wharf were Japanese owned and operated. Wartime expropriation of these businesses and internment of Monterey's Japanese American citizens during World War II ended the Japanese influence in Monterey's fishing economy.

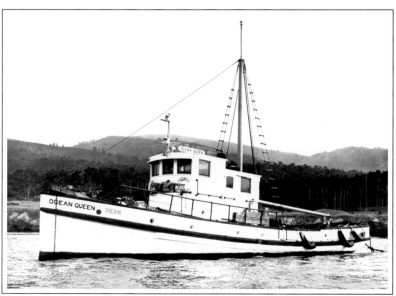

The rum-running Ocean Queen, which became the flagship of the Japanese abalone flotilla operating from the cove at Point Lobos. 1924 photo [83-46-1]

A dive boat is towed from the protected cove, past the cannery at "Whaler's Cove," a name surviving both Chinese and Japanese occupations of the cove.
C. K. Tuttle 1902 [72-08-176]

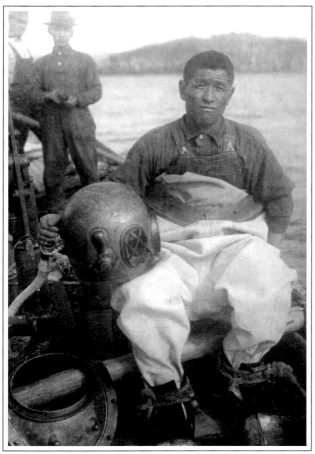

This hard-hat diver, known as Aoki, prepares for the cold, dangerous work of harvesting abalone below. Lewis Josselyn [71-01-PL-06]

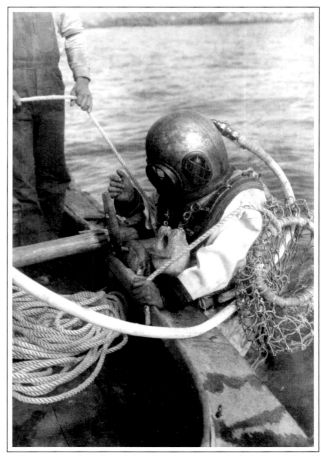

Aoki goes over the side with his abalone net, decades before such diving became an indisapensible function of the Monterey canning industry.
Lewis Josselyn [71-01-PL-05]

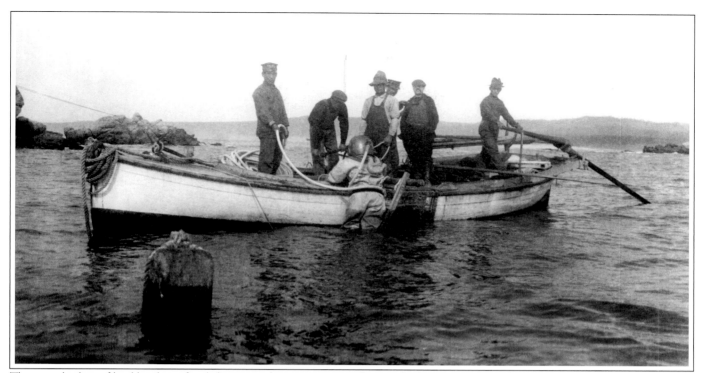

The new technology of hard hat diving for abalone was to have important ramifications for the young sardine industry which was also to become dependent on diving technology. *Lewis Josselyn photo, 1916 [71-01-PL6]*

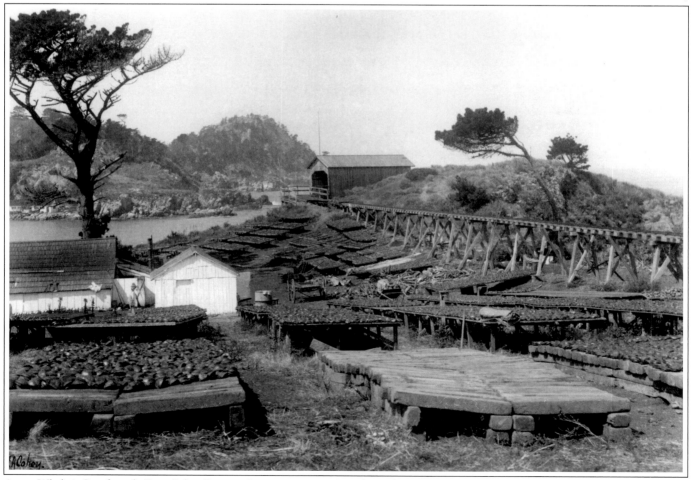

Across Whaler's Cove from the Point Lobos Canning Company cannery, Carmelo Land and Coal Company's unprofitable Coal Chute Point venture was adapted for drying abalone, as seen in this September, 1905, E. A. Cohen photo. [77-03-0202]

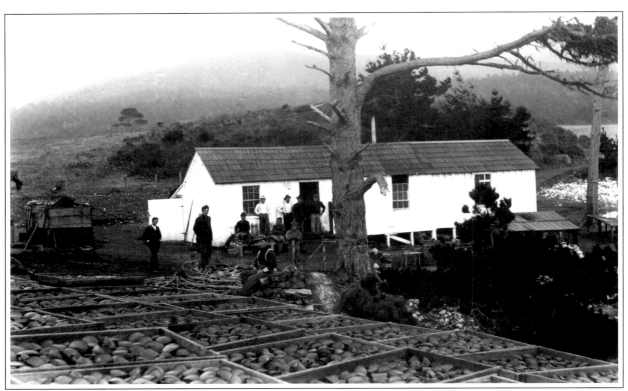

Gennosuke Kodani (seated center) and crew with drying abalone on Coal Chute Point, circa 1905. Although not yet appreciated by American palates, canned minced and diced abalone was shipped to Japan as a delicacy. C. K. Tuttle [72-08-175]

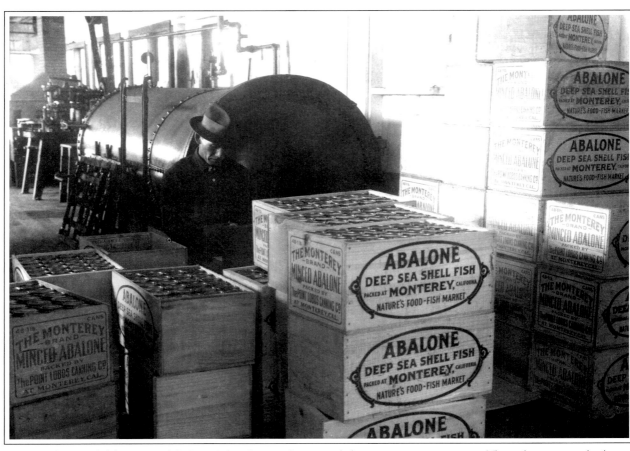

Lewis Josselyn recorded the interior of the Point Lobos Canning Company abalone canning operation, 1916. This early canning technology at point Lobos launched the first canning operation (also Japanese) on old Ocean View Avenue. [71-01-PL11]

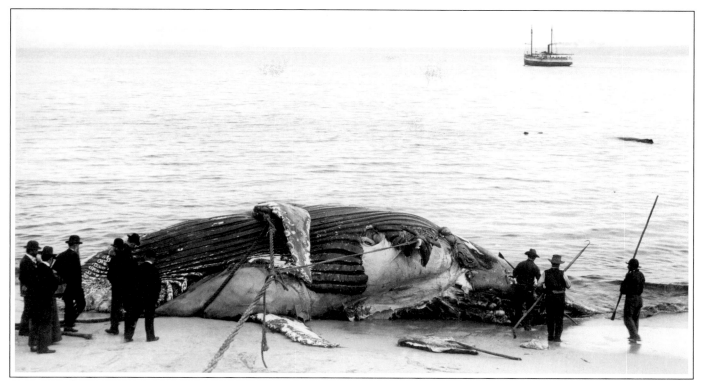

Portuguese shore-whalers flensing a humpback whale on McAbee Beach in the 1890s. Kerosene would doom such whaling at Monterey, vacating this once remote beach for other ventures. *C. K. Tuttle photo. [72-17-36]*

PORTUGUESE WHALING AND McABEE BEACH

Whaling in the Monterey Bay dates back to the Spanish period when New Bedford deep-water whalers anchored in the harbor to resupply for their ship-based assaults on the migrating giants. The grey and humpback varieties were so plentiful, and migrated so close to Monterey's peninsula that, in 1854, Captain John Pope Davenport organized the first "shore whaling" enterprise in Monterey. Its all-Portuguese crews were experienced whalers, many with deepwater and shore whaling experience from their native Azores Islands.

In the years following Monterey's near depopulation by the gold rush, the growth of several Portuguese-manned shore whaling companies must have provided what little excitement could be seen. Longboats were sailed and rowed from shore to meet the hapless targets of harpoon and bomb-lance. A successful strike with the "Greener's (harpoon) gun" ensured a wild ride as the longboat was dragged great distances at high speed behind the wounded whale before it tired and could be dispatched and towed back to shore.

"Try-works" on the shores below Monterey's first Whaling Station and Jack Swan's place, near the Custom House, and later at McAbee Beach on what is now Cannery Row, rendered the blubber into oil as the whales were flensed on the beaches. The stench of boiling whale blubber was another olfactory fact of life in early Monterey, as whale bones were being piled nearly the length of the beach at Monterey.

Kerosene would replace whale oil by the turn of the century as its Portuguese practitioners turned to fishing and farming. The coastal freighter "Gypsy," seen again in this 1890s flensing of ahumpback at McAbee Beach, was to run aground in fog and sink at this site on September 27,1905.

A circa 1907 post card of McAbee Beach as a seaside resort. [83-80-04]

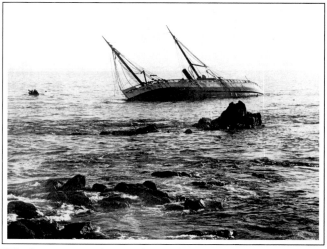

"The Gypsy" aground at McAbee Beach, Sept 28, 1905.

[84-004-006]

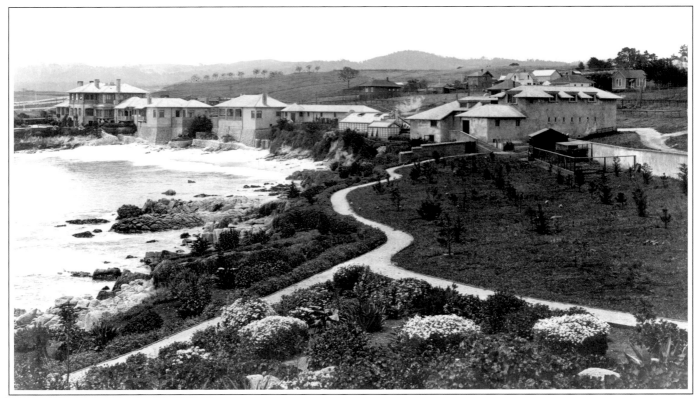

The elegant Tevis-Murray Estate, occupying a thousand feet of coastline, was inspired by the fabulous grandeur of the Hotel Del Monte. The grand Casa de las Olas, "House of the Waves," was built by Hugh Tevis as a summer house for his young bride, a Denver socialite. E. K. Baker [79-43-2]

EARLY GRANDEUR

Certainly influenced by the stately splendor of the grand Hotel Del Monte — and with the added advantage of a sweeping panorama of the Monterey Bay — a magnificent estate was begun on the shores of a sandy beach on Ocean View Avenue in 1901. Son of the wealthy Lloyd Tevis, Hugh Tevis had assumed full-time management of the family investments, including property in Monterey, upon the death of his father in 1889. In 1880, his father had declared the opulent Hotel Del Monte the official family summer residence and entertained lavishly there for many years.

Hugh Tevis' first wife, Alice, died after the birth of their daughter, Alice Boalt Tevis, who was raised by her grandmother. She traveled and vacationed frequently with her father. It was on such a trip, staying at the Del Monte, that she met Cornelia Baxter, a "princess" whom she insisted her father meet.

The gorgeous eighteen-year-old debutante from a wealthy Denver family had been sent to the Hotel Del Monte to recuperate from typhoid. The romance that ensued soon resulted in their engagement in March and their marriage in April, 1901. Hugh's wedding present to his young bride, which was intended as a summer home, was to be completed that September. It was on a trip to the Orient to shop for furnishings while the estate neared completion that Hugh Tevis died in Yokohama from appendicitis. Cornelia and relatives moved into the palatial estate in September, 1901, where she remained until the birth of her son, Hugh, in San Francisco the following February. The mansion would be sold.

The newly sold "Casa del las Olas" (House of the Waves) built by Hugh Tevis, passed quickly through the hands of David Jacks, to be purchased by James A. Murray in 1904. Although not a "Copper King" himself, Murray ascended into the ranks of Montana mining millionaires with a Midas touch in his tough but honest financial dealings. An occasional visitor and heavy spender at the Hotel Del Monte, his wealth required a suitable residence as he eyed Monterey for his retirement with his second wife, Mary, and her son, Stuart Haldorn. His was not a full retirement to Monterey, as he kept up his financial interests while embarking into the arena of local art and history patronage.

Perhaps having been a mining man kept him from objecting to nearby storage tanks and the Associated Oil Company pier that now encroached the view from the "Murray Mansion." But how could James Murray have possibly known the future consequences of the archaic canning experiments in the Booth cannery at the harbor, or at the rudimentary sardine packing shed toward McAbee Beach that would become the Pacific Fish Company. Cannery construction along the once remote coastal road was well underway by Murray's death in 1921.

By early 1941 the estate, surrounded by the noise and smell of cannery expansion, succumbed to that pressure. It sold to Angelo Lucido, owner of the San Carlos Cannery, who soon subdivided the property for sale to cannery and reduction plant development. The halcyon days of the Tevis-Murray estate were over; it was demolished in 1944.

THE McABEE CHINATOWN

The whalers were gone from the beach and little disturbed the tranquility of the nearby Murray estate until the fire that destroyed the major Chinese settlement at China Point in 1906. The fire triggered several important changes: it dispersed a large portion of the once thriving Chinese enclave, it ended the Chinese participation in the further development of the Monterey fishing industry, and it resulted in the successful negotiation for a new but smaller Chinatown at McAbee Beach.

McAbee, a Scotsman, had developed a leisurely seaside tent-cottage and boat rental business just prior to the turn of the century. Summer Sundays were busy with bathers and picnickers in what was to be the last of this beach's recreational enterprises. The nearly vacant beach would become Chinese, over the strenuous objections of Murray and other local dignitaries, as China Point's refugees obtained leases from the Scot.

By 1910 the industrious "newcomers" had erected a somewhat more conventional-appearing settlement above the beach, facing Ocean View Avenue. Included were the Joss House, which had escaped the 1906 fire, and the Monterey Fishing and Canning Company, engaged almost entirely in reducing fish heads and offal from Booth and Pacific Fish Co. to fertilizer —Monterey's first major "reduction" plant. Now inside the Monterey city limits, the Chinese were prohibited from drying squid at McAbee's and moved that operation to the highway toward Salinas, outside city jurisdiction. As more Chinese moved out of fishing, an Oriental quarter grew up at Franklin and Washington Streets in downtown Monterey, containing both Chinese and Japanese. The once proud Ocean View Hotel was built in 1927 above the vacated beach by the Wu Family, Chinese from San Francisco who had run a cafe on Alvarado Street in Monterey prior to their investment on Ocean View Avenue.

In 1929, an Annex to the hotel across the street was built as the Marina Apartments, with matching tile "dragon roofs." Years later it would become another of the brothels for which Cannery Row would become noted. It survives today as the most prominent reminder of the once major influence of the Chinese on the character of Ocean View Avenue.

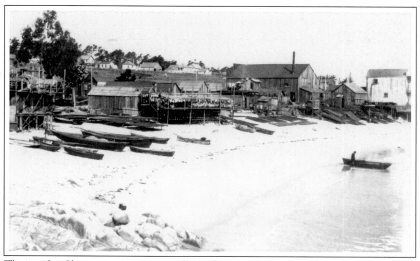

The McAbee Chinatown circa 1911, with its reduction plant (with smokestack), and on the far right, the Joss House—saved by its distance from the fire at China Point—in its second location. J. K. Oliver photo. [73-12-3]

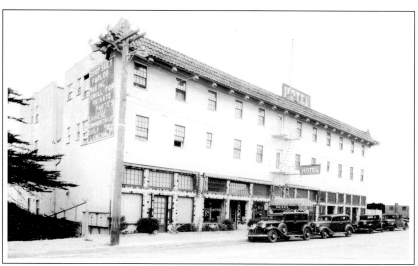

The Wu Family's stylish Ocean View Hotel and restaurant, built in 1927. Photo taken in 1934 by A. C. Heidrick. Photo courtesy of James Wu. [86-051-001]

The Ocean View Hotel and its Annex, the Marina Apartments (built in 1929), during the demise of the canning industry's reign on the Monterey waterfront. Gem photo [91-002-001]

PACIFIC GROVE AT PLAY

The Chinese and their squid drying had been vanquished by fire; their move to New Monterey's McAbee Beach had ended the only other nearby boating and seaside recreation. With a Japanese Tea Garden and other tourist and entertainment establishments completed, Lovers Point in Pacific Grove took on new life.

Among its newly famous attractions was a glass bottomed boat concession, a bath house, a heated salt-water swimming pool, auditorium and photography studio. An even earlier structure —the Hopkins Seaside Laboratory — had opened on the point in 1892, a gift of Timothy Hopkins and the Pacific Improvement Company, the first such research facility to study the marine life on the west coast.

After the fire at China Point, the dilemma as to what to do with the land--earlier marked for development of expensive residential home sites--was resolved. The Pacific Improvement Company donated the land to the University of California for use as a location for a marine research laboratory. By 1918 the Hopkins Seaside Laboratory relocated from Lovers Point to China Point and reopened as Stanford University's Hopkins Marine Station.

Unfortunately, the curriculum did not deal with either salmon ... or the sardine.

IT ALL STARTED WITH SALMON

Monterey's early commercial fishermen were by stock a hardy and independent group, in many ways reflecting the state of the "industry" of the times. The Chinese were doing a brisk business to their San Francisco and overseas markets. The Spanish-speaking "Californios" could boast the first salmon caught trolling, which induced a concerted hook-and-line fleet of sailing skiffs, mostly Japanese, to add this magnificent species to the Monterey inventory. Of all the market varieties being fished in Monterey, none was to be more important to the turn-of-the-century bay area economy than salmon.

Commission agents had ventured to Monterey since the early 1890s to buy salmon for packing plants at San Francisco and the Sacramento River. One such visitor was Frank E. Booth, president of the Sacramento River Packer's Association, who by 1896 concluded that Monterey's salmon supply warranted a local cannery. In 1896, Booth built but shortly closed an experimental salmon canning shed adjacent to the Pacific Coast Steamship Company pier as local fishermen accepted higher bids from San Francisco agents. Their greed was rewarded by lower prices again after Booth's withdrawal.

Booth tried again in 1901, but was no longer the only packer at Monterey. San Franciscan

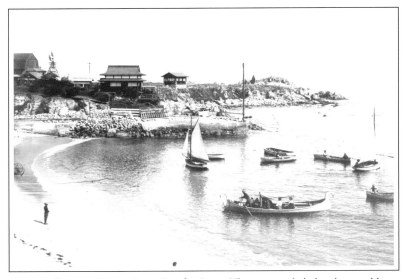

Autumn of 1907 at Lovers Point, Pacific Grove. The swan-necked glass bottomed boats had been built by Russell Sprague in 1886. A "lookout" building and Japanese Tea House (involving pioneer Japanese developer, Otosabura Noda) dominate the point and its entertainments. *C. K. Tuttle [72-08-91]*

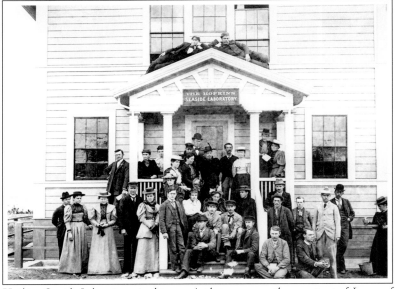

Hopkins Seaside Laboratory, in this 1890's photo, was another occupant of Lovers of Jesus Point until moved to China Point in 1917 as Hopkins Marine Station of Stanford University. *C. K. Tuttle [72-08-80]*

H. R. Robbins had constructed a small wharf, complete with a smoke house and warehouse, also adjacent to the steamship pier. Both operated successfully, but with much difficulty in 1902 before Booth's canning operation was destroyed by fire. Robbin's operation faltered badly and could not take advan- tage of Booth's ill fortune. His experiments in reduction of scraps and salmon waste, however, proved an interesting and somewhat lucrative sideline — but unable to save him. Booth returned in 1903, buying out the entire Robbins cannery.

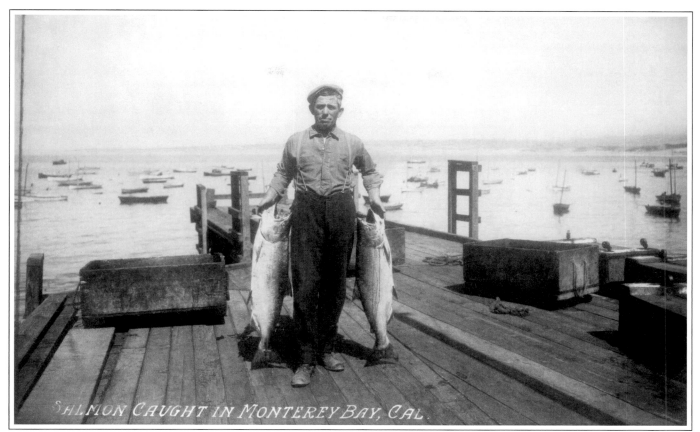

This early postcard clearly explains the initial interests in Monterey as a fishing town. It was salmon like this that brought the fish buyers to Monterey, later to experiment in sardine canning. [86-12-4]

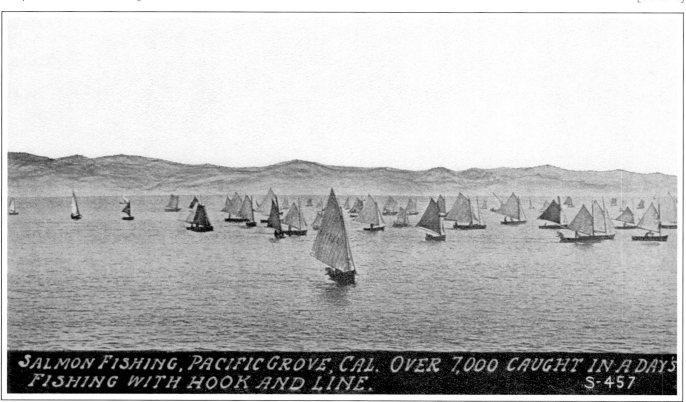

It was salmon that put Monterey on the commercial map at the turn of the century and another postcard clearly reflects the bounty of its beautiful bay waters, with 7,000 salmon caught in a single day by a fleet of predominantly Japanese sailing skiffs. Edward H. Mitchell (Publisher) [78-62-1]

Pioneer Monterey salmon and sardine packer, Frank E. Booth, "Father of the Monterey Sardine Industry." *Habenicht Studios* [78-47-1]

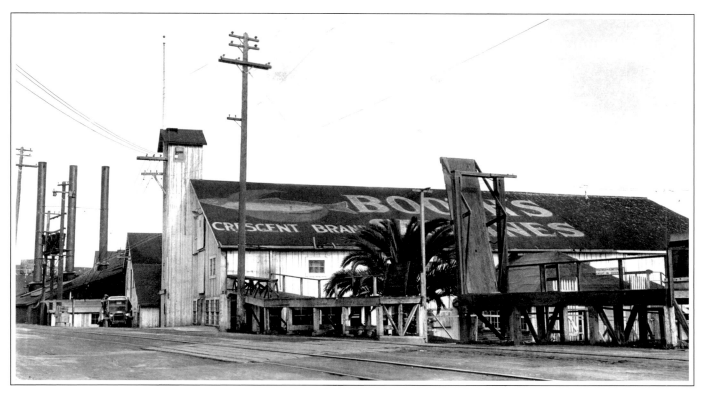

Booth's cannery and it Crescent Brand Sardines proclaimed on its roof sign. Its pollution of the harbor with fish waste and its industrial appearance in the heart of scenic Monterey's harbor did little to endear it to non-fishing and canning interests. All other canneries were made to locate elsewhere--which meant out the dangerously rocky coastline near McAbee Beach and China Point. [87-032-01]

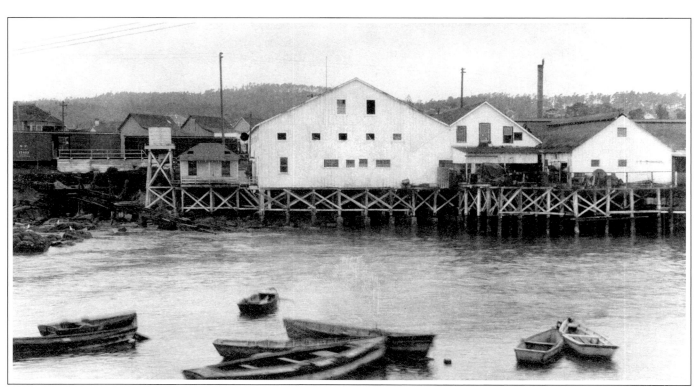

A view of the Booth cannery from Fisherman's Wharf, showing its scale and construction. As with the sardine factories to come, form followed function in the design and construction of Monterey's rapidly expanding fish packing industry. Chester Toombs 1914 [85-019-0079]

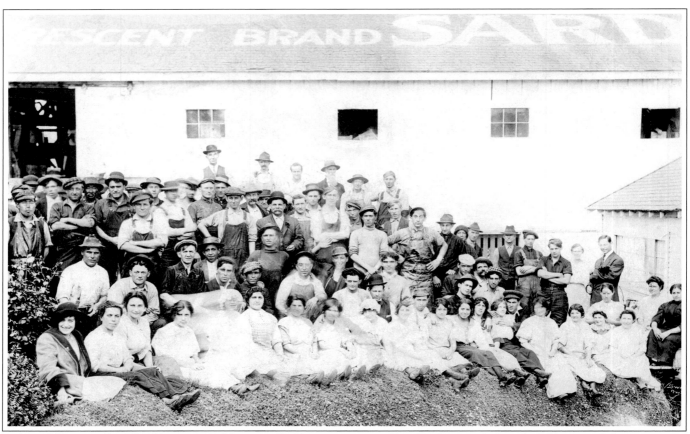

A photo of the crew at Frank Booth's cannery in July, 1914. His Norwegian manager, Knut Hovden, is on the far right, holding a small dog.

F. C. Swain [92-012-006]

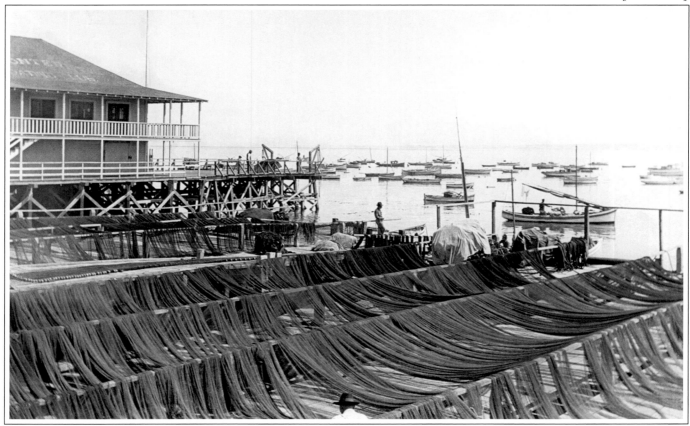

Lampara nets spread to dry at "Ferrante's Landing" adjacent to Fisherman's Wharf. Maintenance of the cotton nets was critical to the fishing industry and their care and repair was of paramount importance. Major net repair was done during the week of the full moon each month of the season (August to February) when fish could not be spotted by their florescence at night due to the moon's reflection on the bay.

A. C. Heidrick [83-082-023]

THE UNSUNG ORIGIN

The entry of Booth's "Monterey Packing Company" consolidation of 1903 into the fish packing business was preceded a year by a rudimentary canning-shed operation begun on the rocky New Monterey coastline. Harry Malpas and Otosaburo Noda, from the Point Lobos Canning Company, opened the first canning operation on Ocean View Avenue. The small- scale "Monterey Fishing and Canning Company" opened in March, 1902, initially packing abalone and salmon. It struggled with the same erratic supplies of fish as Booth and Robbins, but operated with far fewer reserves.

Booth's general manager since 1902 was replaced by the young Norwegian canning specialist, Knut Hovden, in 1905. James A. Madison, who had joined a San Francisco canning company returned in 1907 and with Joseph Nichols negotiated the purchase of the financially troubled Malpas packing business. Another of the investors was Bernard Senderman of Pittsburg. On February 14, 1908, "Pacific Fish Company" was born — the first major cannery on Ocean View Avenue.

"Cannery" requires some explanation and in many ways the Pacific Fish Company is a typical early profile. The delivery of fish was accomplished at a pier, constructed as far out over the rocky shoreline as possible. Fish were cut by hand to remove heads, tails and offal. They were then split and spread to drain and dry on wooden "flakes," or slats. Large flat metal baskets of "flaked" fish were then drawn through long troughs of boiling peanut oil, drained again, packed into cans and hand soldered closed. Labeling and boxing for warehousing and shipment completed the process. This process, with some variation, was common to all the early Monterey canneries. A gifted man was to change all that.

A 1911 crew photo of the draining and drying of cut sardines on "flakes" prior to being "French fried" (French Method) and canned. [81-14-1]

Early post card of Pacific Fish Co. crew with sardines in metal baskets to be drawn through boiling oil to cook the sardines. M. Rieder [79-084-01]

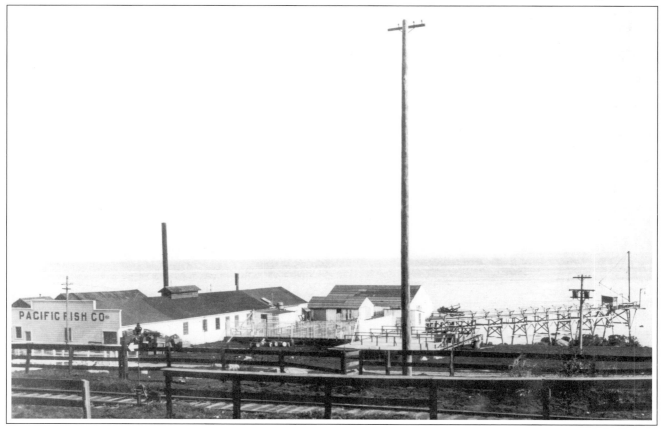

The coastline's first packing operation, Monterey Fishing and Canning Company (1902), became Pacific Fish Company in 1908. [83-41-1]

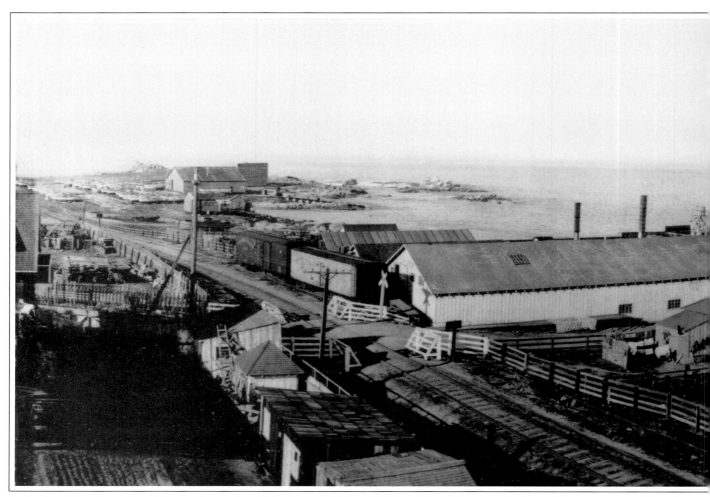

A view from Wave Street shows Monterey Boatworks and the Agassiz Building of Hopkins Marine Station--on the former Chinatown site--and the early

THE PRINCE AND SOON KING

In 1905 the most important man in Monterey's sardine saga took a position with Booth's awkward and poorly mechanized canning operation at the harbor. The young Knut Hovden, a talented graduate of the Norwegian Fisheries College, had immigrated from the North Sea canning industry due to a serious respiratory problem. He brought with him both experience in an advanced canning technology and a gift of inventive genius. The archaic canning procedures he found in Monterey gave him a challenge and opportunity to apply both.

A self emptying "purse-bottom brailing net" was one of his first applied solutions to the arduous unloading of sardines from the lighters (barges) in which they were delivered to the cannery. The canning itself was to benefit enormously from his invention of a mechanical sealer-solderer, permitting an astonishing increase in production capacity. His almost immediate impact on the capacity of Booth's processing was unmatched, however, by a corresponding improvement in the increased capture and delivery of sardines. Both local fishermen and their clumsy gill nets were unsuitable to the expansion of production capacity Hovden had made possible.

The impasse was to be broken by another man of vision and "appropriate technology," a respected Sicilian

fisherman from Booth's Sacramento River operation. Pietro Ferrante represented both the tough Sicilian work ethic and the intelligence to apply a familiar technique utilized by his Mediterranean ancestors — the "lampara" net. Unlike the clumsy and inefficient gill net, which was dragged into a school of sardines which were caught in it by their gills — requiring removal by hand after capture — the "lightning" net in the 1907 experiments at Monterey encircled the sardines and was then quickly closed at its ends to entrap its catch.

Booth's new canning capacity would now soon be matched by a substantial improvement in the delivery of sardines — by Sicilians who knew how to conduct the lampara technique. So would begin the Sicilian mastery of the Monterey sardine fishing industry.

Hovden was soon happily seeking ways to keep canning capacity up with the rapidly burgeoning delivery rate, a situation challenging his inventiveness and an opportunity he eagerly pursued. His processing prowess was to become legend and the opportunity to employ his innova-tions in a canning facility of his own was a certain expectation as he assumed a larger and larger role in the Booth operation. It is appropriate that Frank Booth should be called the "Father

40

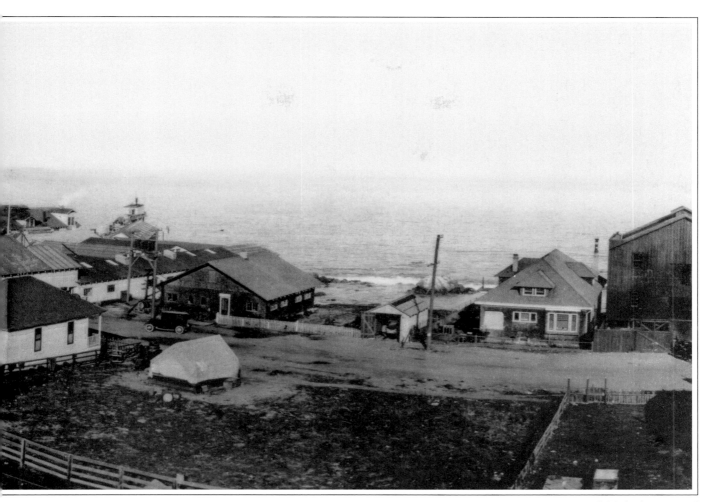

cannery of the Hovden Food Products, Corp. at the Pacific Grove end of Ocean View Avenue, circa 1918. A. C. Heidrick [85-12-1]

of the sardine industry," but the young Hovden would soon be "King."

By 1915 it had become evident to Hovden that his once grateful and cooperative employer, Frank Booth, was stubbornly resisting changes and improvements he sought in the further development of his processing techniques. Hovden's interest in the potentially lucrative reduction and sardine by-product business may have proven the last straw. Without Booth's cooperation, he ventured into a small reduction development which proved a profitable sideline to the existing canning process.

Max N. Schaefer, a vigorous and innovative businessman, was further convinced that reduction could be a major part of the industry and developed full-scale reduction as a separate industrial enterprise. His plant in San Francisco's San Pablo Bay provided the model for his "Monterey Fish Products Company," which opened in 1915 on Cannery Row.

Hovden submitted his resignationn in November, 1915, and with the support of local financier and real estate man T. A. Work, opened the "Hovden Cannery" at the north end of Ocean View Avenue on July 7,1916. Once Prince, the King had now arrived.

A "Salachini" dried, salt-pack sardine with canned anchovy in a display in an unidentified packing operation. Brine-curing sardines continued with less success as the 1920s neared and canned sardines surpassed this "Old World" method of preserving fish. [99-071-001]

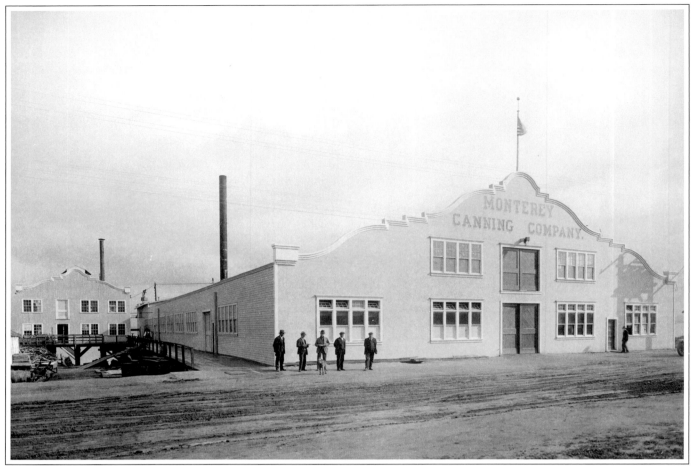

In 1918, Point Lobos canner Alexander M. Allan and George Harper entered the fish packing industry in Monterey at the height of World War I, with their Monterey Canning Company. A. C. Heidrick [86-060-001]

THE STARTING GUN

Assuming a position at the head of the pack he would never relinquish, Hovden's entry into the sardine packing industry could hardly have come at a better time. The "Great War" was to shut down the North Sea fishery, leaving Monterey's inexpensive, high-protein sardine pack in high demand as a wartime ration. By war's end, Booth, Pacific Fish, and Hovden canneries would be joined by: California Fisheries Company, a Japanese export firm; Bayside Cannery near Hovden's; Monterey Canning Company, owned by George Harper and A. M. Allan of Point Lobos abalone canning; San Xavier Canning Co. near the Tevis-Murray estate; What was to become Carmel Canning Company, for Bernard Senderman, early partner in Pacific Fish Company; E. B. Gross Cannery, near the Tevis-Murray Estate; and a brick reduction plant on Foam Street for the late entry of Frank Booth to the by-products business, joining Max Schaefer's Monterey Fish Products Co. in major reduction processing.

Cannery Row's wartime production would grow from 75,000 cases in 1915 to 1,400,000 cases in 1918; the price per case rose from $2.14 to $7.50 through that same period. The apparent result of World War I on Cannery Row was to provide the investment incentive to develop and mechanize the canning industry at Monterey. It was also an important step in helping overcome resistance in world markets to the large Pacific cousin of the widely accepted Atlantic Sardine. In the United States a domestic market had hardly existed. This unprecedented wartime bonanza was, of course, too good to last; recession set in as the guns cooled.

Perhaps quaint by current standards, the rugged, highly competitive sardine canning business resulted in canneries and warehouses of strictly functional design, although some bore barn-like advertising of the day.

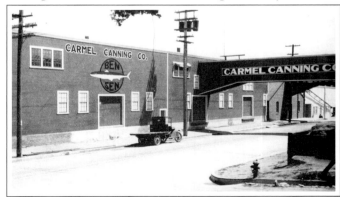

Carmel Canning proclaims its "Ben-Sen" brand, named after its builder, Ben Senderman, who sold out before its completed construction. [83-41-2]

A glimpse down Cannery Row in the aftermath of the war would show a boomtown of corrugated canneries perched over a rocky coastline, unloading sardines from offshore by cable and bucket — 600 pounds at a time. Although canning had been significantly mechanized, labor continued a major factor in production.

In an age before telephones in the working class home, the cannery workers were called to work by cannery whistle; each cannery had a distinct pitch and pattern. Working hours were dictated by the arrival and size of each day's catch. Work itself was generally cold, wet and smelly, in drafty plank and tin canneries where the din of steam, cascading cans and the roar of equipment often drowned out an orchestra of international languages spoken in the primarily Chinese and Japanese cutting rooms and sheds — the Spanish, Portuguese, Sicilian, Mexican and English of the canning lines — and the shouts, grunts and curses of the warehousing crews.

Monterey's initial displeasure with the odors from Bobbins' early salmon reduction experiments around 1902 were merely memories. But the smell of reduction would become, in the decade of the twenties, a problem of major proportion. The Chinese at McAbee had led the Row into reduction and its wrenching smell, augmented by Hovden's similar interests and the success of Max Schaefer's leadership in the processing technique. Even the stubborn Frank Booth had succumbed to its profits and utility. The net effect was a well-earned reputation best summed up by a saying of the times: "Carmel by the Sea, Pacific Grove by God... and Monterey by the smell!" But in these uncertain times it was also "The smell of prosperity." The industry and its work force tolerated it; the City of Monterey objected to it; the Hotel Del Monte's Samuel F. B. Morse was infuriated by it. And yet because the industry's continued survival— at least as it was structured — depended on it, the death-like stench of the reduction process should have been seen as a warning of impending consequences requiring effective resolution.

The canning process also changed significantly as a result of the production demands of World War 1. The original French Method of frying in oil was almost completely replaced by mechanized steam cooking in sealed cans, by crews that lived above the Cannery Row waterfront in the district called New Monterey. The industry's expansion happened in an American age before income tax, so the huge

(Continued on Page 45)

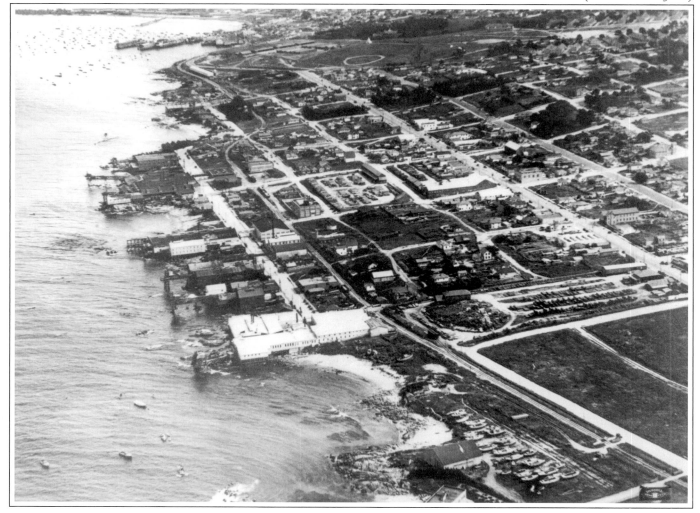

This early 1920s aerial view of Ocean View Avenue and its growing canyon of canneries prior to the construction of the large American Can Company can making plant on the open slopes above the Monterey Boat Works at China Point. *G. E. Russell Aero Photo [79-110-03]*

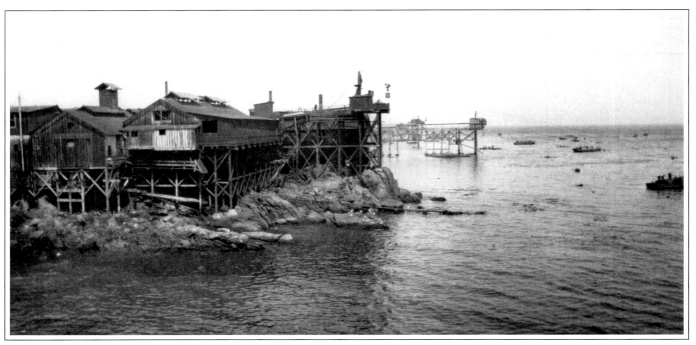

Monterey's canneries were forced to locate outside the harbor on the rocky coastline along Ocean View Avenue. Underwater rocks and sea-mounts made it a trecherous unloading area for Monterey's fleet. Cable lines for steel buckets were rigged from fish towers high on the canneries, such as seen in this circa 1927 photo of Cal-Pac and Carmel Canning Co. canneries, unloading lighters safely offshore. [73-20-014]

A night's catch had to be unloaded from lampara lighters (barges) a bucket at a time up the cables to the fish towers at the canneries. The steel buckets held roughly 600 lbs. of fish. Lighters could hold up to 40 tons. [73-020-012]

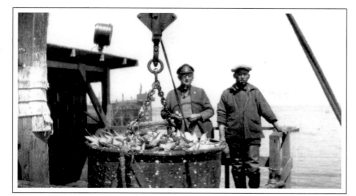

An off-loading system that would soon change. [73-20-13]

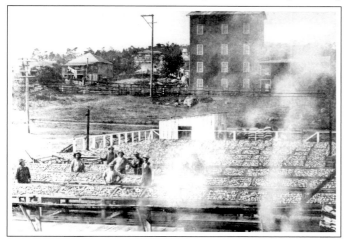

The "French frying"° would fade quickly after World War I. [76-07-3]

profits from the good times in the industry were often the windfall Steinbeck alludes to in his introduction to *Cannery Row*, in which he muses that some canners were upset if unable to recover their entire investment each season. This was, of course, a stretch of the imagination, but not entirely without basis.

Conditions in the canneries were at first archaic, to say the least, and unsafe under almost any assessment. Open gears, live steam, chain drives, and canvas belt-to-wheel drives proliferated in an inventory of dangerous machinery and equipment —in addition to the risks in the hand-cutting of the catch with knives and the inevitable nicks and accidents associated with even expert cutters.

There were at first no controls on hours or shifts in the industry. Workers were called to the canneries by whistle, often before dawn, to pack the night's catch being unloaded by bucket and cable off Cannery Row. Work continued until the day's catch was canned—whatever time that took. A day's work could be six hours, or sixteen hours. These conditions prevailed decades before disability, medical plans, workmen's compensation insurance, child-care, or pensions. It would be the late 1930s before union activity would effectively change the working conditions prevalent in the canneries and reduction plants of Ocean View Avenue. Until then, a look around would find a largely immigrant, multi-cultural work force, many of its workers struggling in near poverty— laboring under crude and arduous conditions in a seasonal industry whose owners and investors cast the dice of fate each season in which fortunes were made or lost on the strength of the sardine's seasonal return and the international market for the large Monterey pilchard.

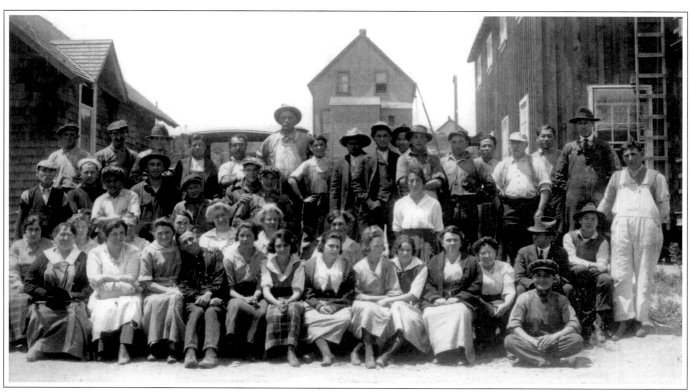

Ocean View Avenue canning was a truly international pursuit, from its markets to its multi-ethnic workforce. This photo of the crew of the Japanese owned Bayside cannery is a typical record of the muliti-national labor force in Monterey's burgeoning sardine canning industry. [78-01-013]

The powerful Pacific was to shake any complacency from its Monterey mariners with its periodic ravaging of the unprotected fleet; no breakwater would be constructed until the early thirties. The worst such storm destroyed 93 lampara boats on the Monterey Beach on Thanksgiving, 1919 — an especially heavy blow given the post-war recession in the fishing and canning industry. It would take another "natural" disaster to provide the protection the harbor needed.

The nearby petroleum storage tanks which Murray had ignored when purchasing the Tevis Estate were struck by lightning on September 14, 1924. The fire lasted for days before exploding into a river of flaming oil running into the sea. In its path were the canneries of California Fisheries and E.B. Gross — and the Tevis-Murray estate. The canneries were destroyed and the mansion and its massive windmill only narrowly escaped the same fate. The Associated Oil Company Pier — which loaded tankers bound for Richmond — was destroyed completely as the oil, blazing on the bay, drifted perilously toward Fisherman's Wharf... until the wind and tide changed!

Only two weeks later, on the night of September 28, the luxurious Hotel Del Monte burned to the ground for the second time. It would reopen, redesigned, the following May.

Fire would also call on Knut Hovden ... twice. The first major fire on August 12, 1921, destroyed the cannery in a fire that lasted two days fed by vats of sardine oil. Hovden's reconstruction included a larger and more modern plant. The second fire occurred October 5, 1924, gutting the reduction plant in a $20,000 inferno. But the King of Cannery Row each time rebuilt, although at great difficulty in the recession-plagued early twenties.

Fisherman's Wharf and Booth were not to escape the call of fate. By the first of March, 1923, canneries had loaded the wharf with twenty thousand cases of sardines for shipment on the freighter "San Antonio." Without a breakwater yet to shield the harbor from unpredictable swells, the "San Antonio" lurched against the Wharf, damaging it and dumping 8,000 cases of still-to-be-loaded sardines into the bay.

Frank Booth was to be the victim of a similar fate on February 2, 1927, when 4,000 cases fell through the floors of his warehouse into the bay. The twenties had, indeed, "roared" in Monterey.

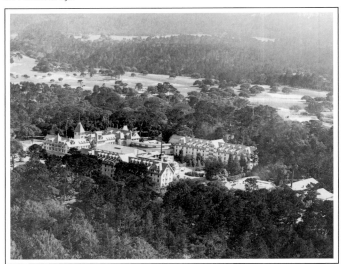

Hotel Del Monte in a Russell Aero Photo circa 1920. [81-006-07]

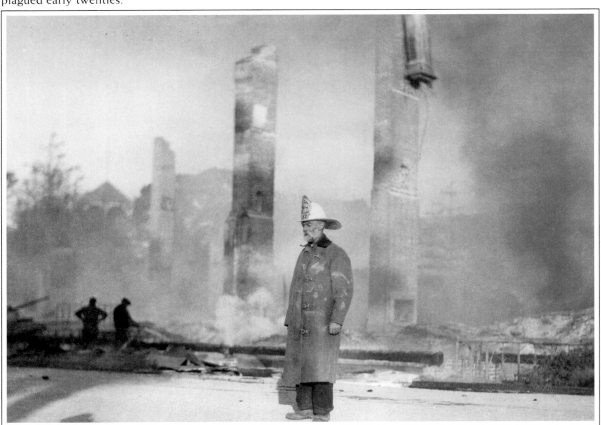

Monterey's first Fire Chief, William "Billy" Parker, stands amid the ruins of the smouldering Hotel Del Monte, September 28, 1924--the second time the luxurious hotel had burned to the ground.
Lewis Josselyn [71-01-0122]

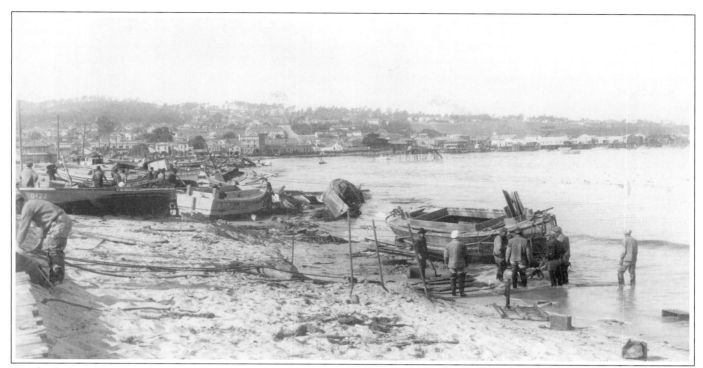

On Thanksgiving Day, *1919*, a devastating storm struck Monterey's exposed harbor. A protective breakwater would not be constructed until *1934*. The storm struck the vulnerable fleet at anchor, destroying nearly one hundred lampara boats and lighters. This disaster came at an already poor time in the recession plagued industry's post World War I recovery.
Lewis Josselyn [71-01-0311]

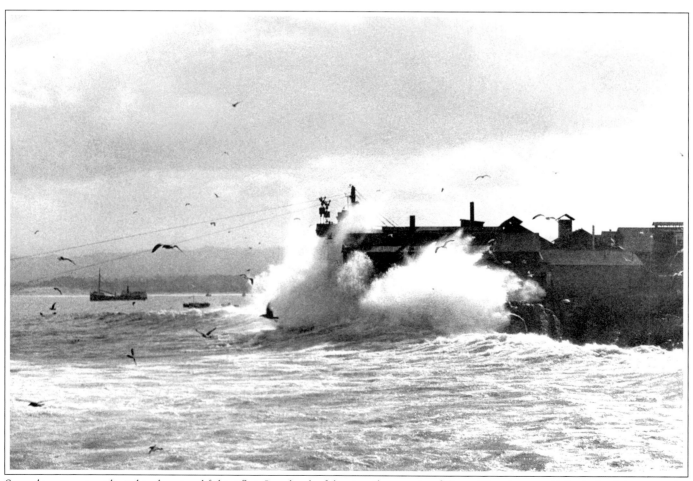

Storm damage was not limited to the exposed fishing fleet. In a decade of disasters, the canneries of Ocean View Avenue paid dearly for their construction on the shoreline. This A. C. Heidrick photo shows the Carmel Canning Company deluged by huge storm waves on Febraury 26, *1927*. [87-050-001]

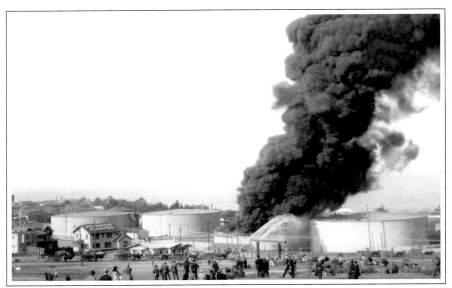

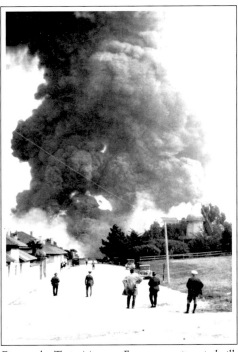

On September 14, 1924, lighting struck petroleum storage tanks above the Associated Oil Company pier (now the location of the Monterey Coast Guard Station) that stored crude oil from a pipeline originating in Coalinga. Crude from these tanks was bound for Richmond refineries. Dan Freeman captures the conflagration before it engulfs fellow photographer A. C. Heidrick's studio. [89-29-00]

Fire at the Tevis-Murray Estate, near its windmill, September 14-16, 1924. [87-019-001]

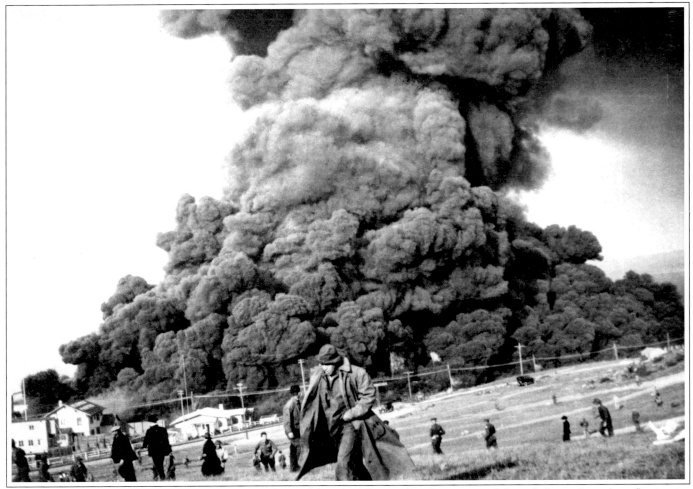

After several days, the uncontrollable blaze resulted in an explosion of the tanks, killing two Presidio servicemen fighting the fire, and roared in a flaming river through the E. B. Gross and Califorinia Fisheries canneries and onto the bay. The Tevis estate and its windmill narrowly escaped the inferno.

Dan Freeman photo [85-11-10]

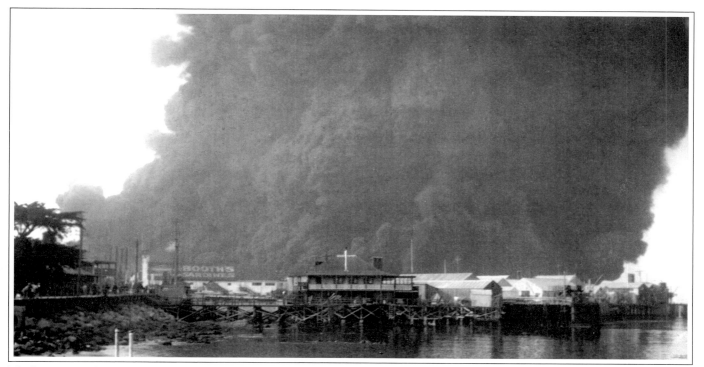

The flaming river of oil spread onto Monterey Bay and was being swept toward Fisherman's Wharf. *Dan Freeman* [82-29-29]

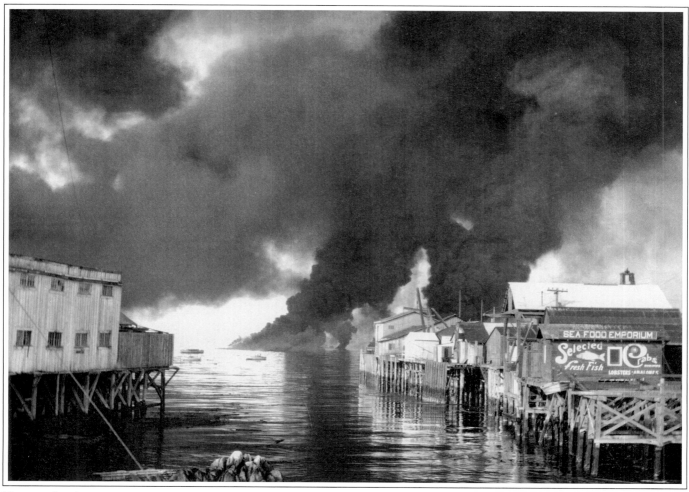

The eerie inferno burning on Monterey Bay consumed the Coalinga Oil and Transportation Pier, a number of hapless boats, and was about to reach the pilings of Fisherman's Wharf when the wind and tide changed. In this photo, the Booth cannery at left, and the Wharf, watch the fire burn out in a near miss.

Dan Freeman [89-029-00]

METAMORPHOSIS

It was as if the whole of Monterey was caught up in a sudden, accelerated transformation. The sleepy, isolated pueblo of Spanish Monterey was suddenly all but gone — except for the few adobes and other early Monterey architecture saved from demolition in the awakening of a new civic consciousness. A momentum established in the twenties would carry Monterey into the decade of the thirties, including its Depression, propelled by sardines!

Lingering memories of whaling along these shores, a Chinatown, and the graceful feluccas of its early fleet were quickly fading into the realities of boatyards, choruses of cannery whistles, and the steady growth of a fishing and canning industry upon which Monterey would become too dependent. Where had the little town gone? The answer lay in sardines: a town and nearly its entire economy was becoming tied up in, serving or prospering in the commerce of one of the world's greatest natural resources, Sardinops caerulea.

As long as the supply of sardines held out —and with little expression of concern except the biennial Department of Fish & Game reports of the imminent depletion that must be coming, but could not be proven — invention and investment had become partners with work and pay. It was the convergence of technical advances and commercial opportunity that would doom the 12-inch fish that greased the gears of prosperity in a decade that first had to rise from the greatest depression in our nation's experience.

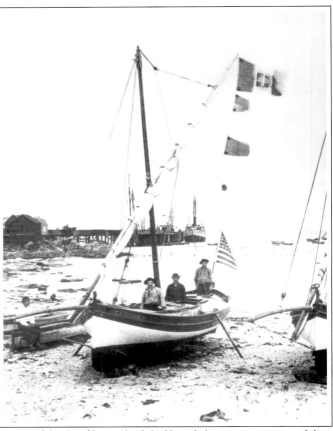

The graceful Italian feluccas that helped launch the stuttering Monterey fishing industry were soon only memories in a commerical momentum that would grow to overpower its own best interests. [83-30-1]

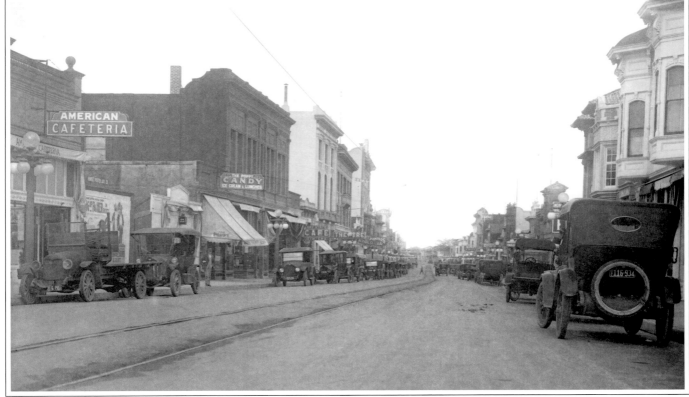

Alvarado Street, 1920, with its street-car tracks and establishments, including the Poppy—used in John Steinbeck's "Sweet Thursday"—and the Bay State Cafe of Mr. Wu, who in a few more years would build the Ocean View Hotel. R. J. Arnold photo [78-36-3]

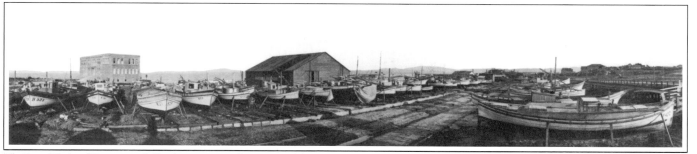

The Boat Works of Pearson and Chochran, 1918, where many of the Monterey lampara boats were built.　　　A. C. Heidrick photo [82-40-1]

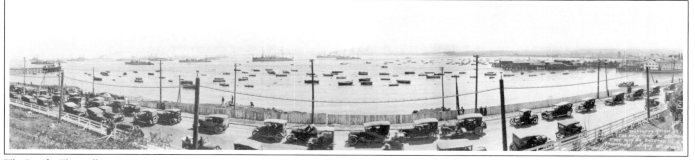

The Pacific Fleet calls on Monterey on August 31, 1919. Monterey is still without it a protective breakwater.　　　A. C. Heidrick photo [79-104-3]

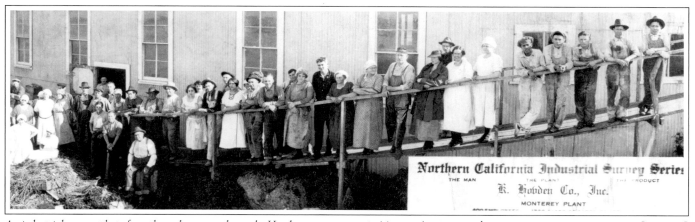

An industrial survey photo from the early 1920s shows the Hovden cannery crew in Monterey's primary industry.　　　[86-52-1]

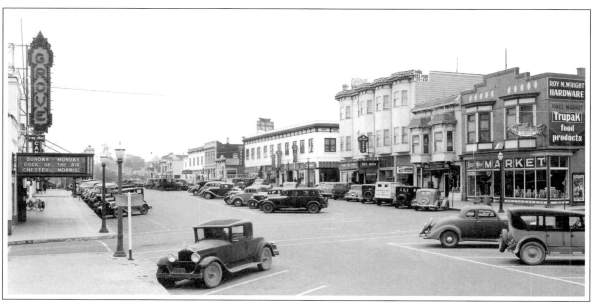

Lighthouse Avenue, Pacific Grove, 1932, in a community rapidly emerging from its staid origins as a Methodist summer retreat. Both Ed Ricketts and John Steinbeck lived here.　　　Lewis Josselyn photo [71-01-263]

THE MEN, THE BOATS

Pietro Ferrante, Orazio Enea, Salvatore Russo, Constantine Balbo, Marco Lucido and Salvatore Lucido--men fated to come to Monterey in 1907 from Black Diamond (now Pittsburg) on the Sacramento River--set out in the "Crescent" and "Queen Esther" on a Monterey experiment with a Mediterranean net for a fish other men still had to learn to can. Their success saw the romantic felucca's that once dotted the bay with their lanteen sails, yield to "Monterey Clippers" towing lighters of fish back to the harbor or anchoring off Cannery Row to unload by bucket-and-cable.

The success of the lampara boat and its role in cannery supply seemed a near perfect match for the predominantly Sicilian immigrants that first manned, and then owned them. Their cost and that of the net was within the reach of many of the fishing families being established on the hill behind the harbor. Several men and a great deal of hard work could produce a good, if frugal livelihood--even ownership of a good and lucky boat. But they had set in motion forces that would soon make the ever improving technology the master, not the servant, of the men who followed its call to the sea.

The insatiable appetites of Monterey's canneries and reduction plants now required a far more complex organization of the means of supply. Establishing the season price between canners and fishermen grew more complicated as the number of boats and owners multiplied into the 1920's. An effective strike for a price increase by the combined boat owners and fishermen in the 1927 season was to bring far-reaching consequences, again at the hands of technology. Hovden threatened to break the strike by bringing boats up from San Pedro, which as a tuna port brought into the sardine business by World War I, was far ahead of Monterey in vessel development.

On July 19, 1927 the purse seiners "Admiral" and "Agnes S." cruised into Monterey Bay. The vessels were larger and swifter than anything Monterey's lampara fleet could have imagined. Their size, at over fifty feet in length, incorporated a protected wheel-house and cabin, large diesel engines, power winches for the huge purse seine (net), a revolving turntable aft on which the net was stacked for rapid redeployment and a hold capacity of thirty-five tons! It meant no more lighters to be towed, a range that opened up new fishing grounds, and an enormous net that closed at the bottom to securely entrap far greater amounts of sardines at a time than a canner's dream. A month later the strike was settled in a compromise, but Monterey had again been changed forever: the means by which the unconscious depletion of the sardine could be accomplished had arrived.

The introduction of the purse seiner brought with it a wave of controversy in the boat owners and fishermen's ranks. A show-down of old friends led "Pete" Ferrante into retirement as Orazio Enea's demands for a "closed shop" organization of boat owners and fishermen heated up a tangled series of organizational attempts dating back to 1914. The reconciliation also had an interesting side effect. Won Yee, the squid baron of Monterey, had used the internal division of boat owner groups for years to form a squid marketing monopoly in which the Sicilian rivalries insured the depressed price of squid, much to Yee's stoic benefit. Sicilian lampara technology, which had eliminated the Chinese from their own squid fishing industry, had made unwitting restitution.

The cost of entry into this new age of big boats and huge nets was, of course, astronomical by Monterey standards. A "half-ring" net, resembling the purse seine, was installed on most of the lampara boats as a stop-gap measure. Requiring little modification to the boats, it could capture nearly the same tonnage as the early purse seine--but still required the use of the accompanying lighter in which to put the catch. The purse seiner age had arrived amid resentment and controversy in the lampara entrenched industry at Monterey.

In an ironic twist, the "Admiral" sank in January 1928, fortunately without loss of life, attempting to haul in an oversize catch. The first small Monterey-built purse seiner, the "Santa Lucia," joined the fleet the following season under contract to the E. B. Gross Cannery. Legislation in 1929 also established the Monterey sardine season between August 1 and February 15. Within the next few seasons the replacement of the lampara by half-rings was followed by new and even larger purse seines and seiners, setting the stage for an awesome new fishing capability centered around the new wolves of the sea.

Through the thirties the expansion of the Monterey sardine fleet and matching canning capacity would record annual tonnage landed at Monterey in excess of 200,000 tons per season in 1934-35, 1936-37, and 1939-40. The decade of the thirties was to be fraught with controversy and confrontation, almost entirely involved in the resolution of the quantities of fish the industry was to take, and what was then to be done with them. The agonizingly slow recovery from the Depression made reasoning even more difficult as the industry argued that its very survival rested on increased limits for reduction of whole fish.

Open reduction at sea by freighters converted to floating reduction plants resisted effective controls by operating beyond territorial limits until stopped by legislation in 1938. Deliveries to these "floaters" were made directly from purse seiners, whose nets were typically over a quarter of a mile long and extended to a depth of ten stories! Only time would reveal the awesome efficiency of this off-shore conspiracy.

Table 8, on Page 83, under the heading "Reduction Ships," shows that in the 1936-1937 season, reduction ships accounted for more tonnage of sardines than all the sardines landed at the canneries in Monterey combined.

Monterey's Sicilian immigration was drawn predominantly from the fishing villages and islands around the capital city of Palermo.

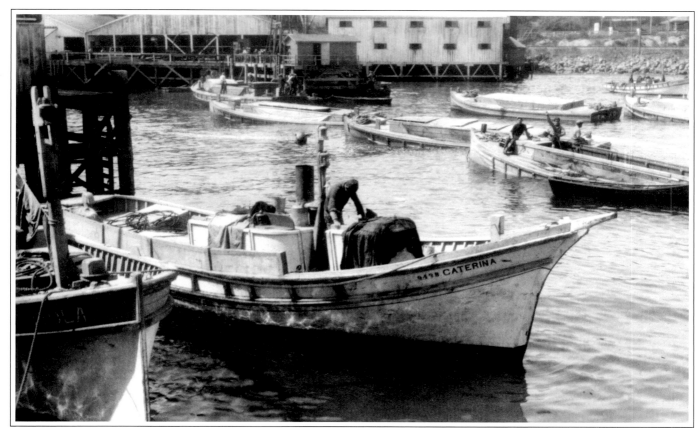

Nino DiMaggio's "Caterina" at Booth's with lighters, is typical of the "Monterey Clipper" design utilized by the Sicilian lampara fishermen of the 1920s. Powered by a Hick's one cylinder, two-cycle engine, its unique bow design deflected waves. Famous as one of the most stable boats ever built. [74-20-10]

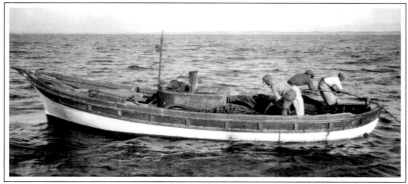

A 1927 photo of Vito Bruno's clipper, "Violet"--carrying a crew of six and the lampara net that had to be pulled in by hand--towing its lighter. Roger Chute photo [89-004-01]

Pietro Ferrante, Sicilian fishing pioneer, introduced the lampara net and brought Sicilian fishermen from Booth's operation at Black Diamond on the Sacramento River (Pittsburg) to Monterey to use it. Thus began the Sicilian mastery of the Monerey fishing industry.

A. C. Heidrick photo [96-005-001].

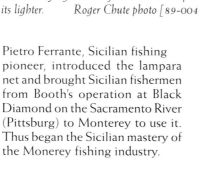

A rare view of a lampara boat at sea from its lighter, into which the fish had to be transferred from the net.
Roger Chute photo [89-004-01]

53

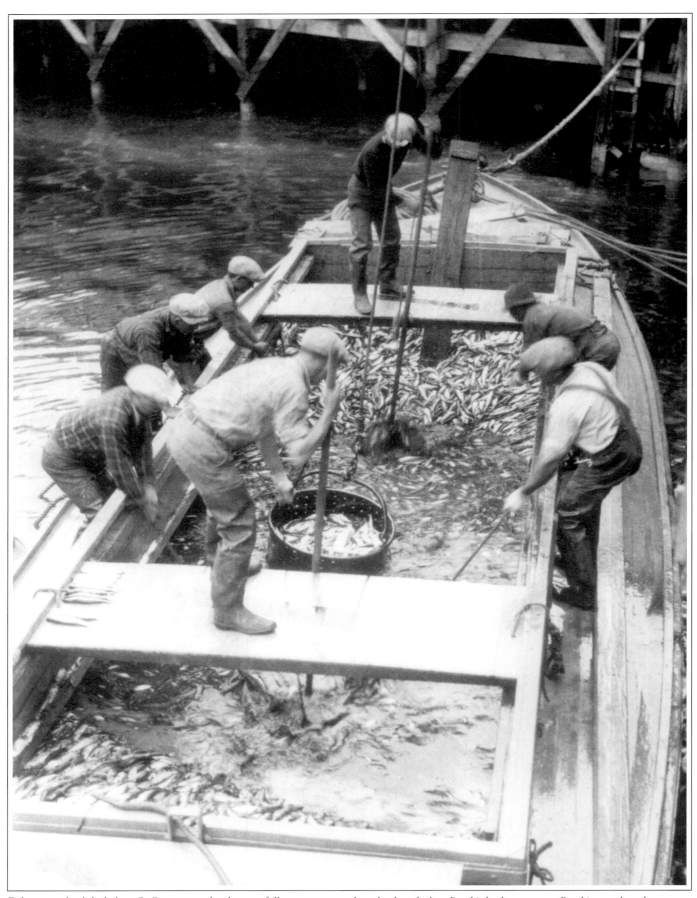

Fishermen unload the lighter, S. Oyama, one brailing net-full at a time up to the unloading dock at Booth's harbor cannery. Booth's was the only cannery where boats couuld tie up next to the unloading facility; others had to use cable and bucket off Cannery Row. [74-020-01]

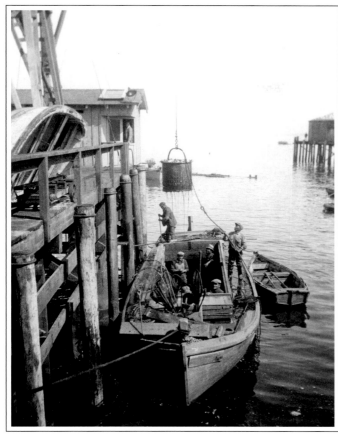

Unloading a lighter (towed barge) of sardines at Booth's cannery in the Monterey harbor, the only cannery with dockside off-loading. At Cannery Row it was done by an arduous cable and bucket process. [87-032-03]

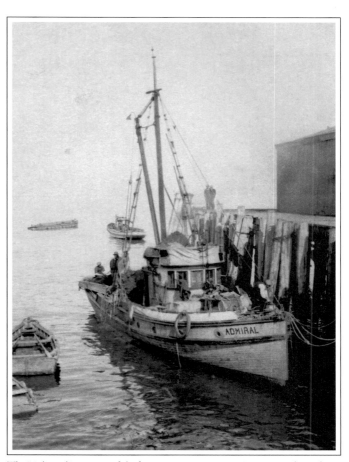

The "Admiral" was one of the first two purse seiners at Monterey--brought up from San Pedro by Hovden to break a lampara fisherman's strike. [74-20-33]

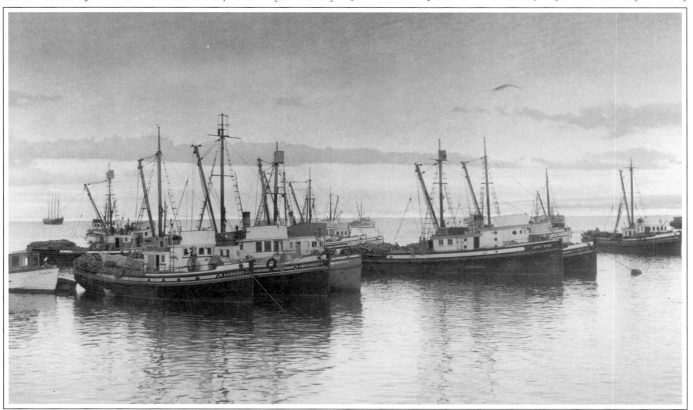

Early purse seiner fleet at anchor at Monterey before a night's work with nets over a quarter mile long and ten stories deep. Chester Toombs [85-019-074]

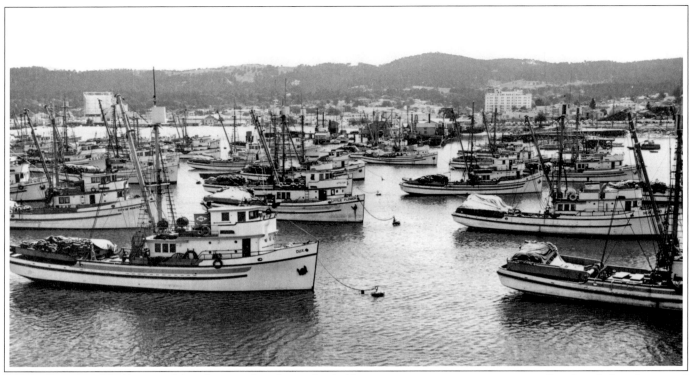

Peak-season picture of the Montrerey fishing fleet at anchor, often one hundred boats or more. *Ray Ruppel photo [74-08-02]*

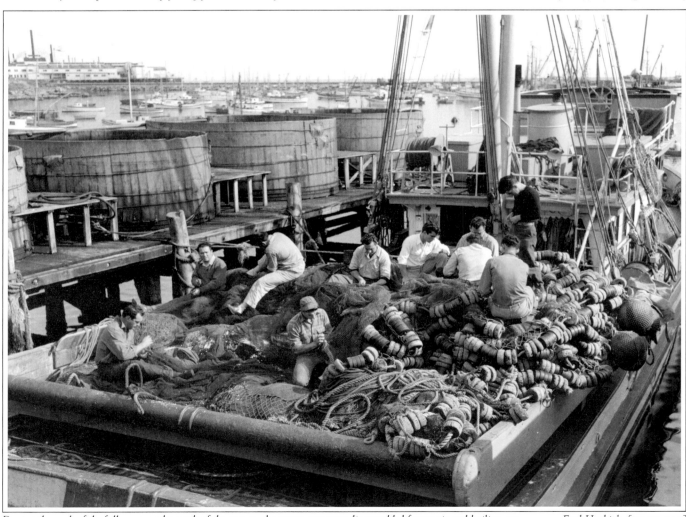

During the week of the full moon each month of the season, the cotton nets were disassembled for repair and boiling out. *Fred Harbick [73-06-015]*

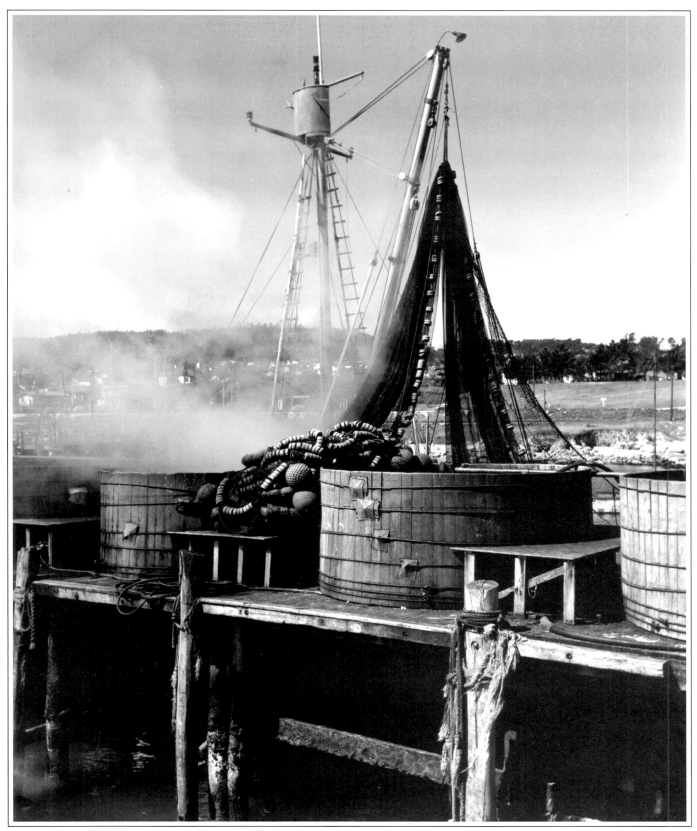

In an age before modern mono-filament nets, the maintenance of the huge cotton-cord nets of which the purse-seine was made required regular, periodic cleaning in order to preserve the cotton fibers from damage by the oils and acids of the fish captured in them. Tan bark, often from Partington Ridge, Big Sur, was used for the tannin solution in which the nets were boiled to purge the damaging chemicals absorbed by the cotton. Nets then had to be skillfully reassembled by the crews for use as soon as the moon darkened and moonless nights helped spot the green flash of phosphorescence of sardine shoals.

1947 Fred Harbick photo [89-030-089]

MISCONCEPTION AND TECHNIQUE

Perhaps the two most frequently misunderstood factors in the saga of Monterey sardine history concern the fish themselves and the technique of their capture. The first misconception concerns the size of the Monterey sardine--or pilchard--which routinely reached eleven or more inches in length. This is obviously not its finger-sized Atlantic cousin still so popular, and in commercial supply by a number of nations still in the trade. The large size of the Monterey sardine, and the weakness of a dependable domestic market made it a difficult food commodity to promote: American acceptance of canned fish of this type remained traditionally low except during wartime ration demands. Peacetime overseas markets met stiff and systematically subsidized competition by Russian, Japanese, South American and North Sea industries.

The second, and perhaps even more interesting misconception involves the fishing technique: it was conducted almost exclusively at night. Finding vast schools of sardines required far more than fisherman's luck: the experience of the skipper was of the utmost importance. The trained eye and experience of a seasoned skipper and crew could spot the "green flash" of phosphorescence on the dark waters of moonless nights caused by the turbulence of millions of schooling fish. Real skill could distinguish between sardines and a time and effort wasting--and occasionally disastrous catch of anchovy--or horse mackerel. Anchovy could plug the "bag" of the huge net and their oily acids could almost dissolve a cotton net if not dragged back to the harbor and boiled out immediately. The skipper's experience was paramount.

"Making a set" with a net a quarter of a mile long, being deployed off a moving boat on the open sea in nearly total darkness (lights drew company and competition) required courage, skill and a level of teamwork difficult for the uninitiated to envision. Although often referred to as "Italians," the men whose labor and skill dominated the Monterey fishing industry came from the coastal cities near Palermo, Sicily. Any Sicilian will be happy to explain the difference. (Refer to page XX)

The set began by dropping the skiff off the back of the seiner, to which was attached one end of the net. The crewman in the skiff deployed a sea anchor, a parachute-like device that when submerged acted like a brake, allowing the purse seiner to pull away on its arc through the portion of the school of sardines selected by the skipper. Remember the "Admiral": take as much as you can, but take too much and its all over. The Seiner completed its encirclement of the catch to connect its end of the net to the skiff. A cable running through rings at the bottom of the lead-weighted net was drawn in by winch to purse the net below the fish.

The boom and tackle lifted the net to the turntable as the power-winch drew in the pursed net until the last section of the net, the bag, drew alongside the purse seiner. It was only then that the skipper and crew could inspect and measure the catch, often several hundred tons, to ensure that it met minimum length specification for acceptance by Fish & Game inspectors at the canneries. This brings us to another major factor in the sardine supply: a catch of sardines of an average size too small to be landed at Monterey was dumped at sea — usually killing nearly all the sardines taken in the set. This kind of loss at se-- before the excesses in reduction of delivered fish--is inestimable.

A large dip-net, resembling a horn of plenty when tipped and emptied into the seiner's hold, transferred fish from the bag to boat. If the bag contained more sardines than the capacity of the seiner's hold, it was common to pour the excess fish onto the walkways and deck, which was referred to as a deck load. For exceptionally large catches, sharing the extra fish unable to be carried was common among friendly boats.

In the early thirties the cable-and-bucket method of off-loading fish to the canneries of the Row was at first augmented, then replaced, by a system of floating wooden pens, or "hoppers," anchored safely out from Cannery Row's treacherous shoreline. The hoppers, introduced by Hovden in 1927, were connected by large flexible hoses to the underwater pipelines to the canneries, which employed massive turbine pumps to literally suck the sardines ashore for processing. This major innovation solved the tremendous problem of quickly unloading large quantities of sardines from the increasing size and number of lampara lighters and purse-seiners entering the fleet.

- Monterey's sardines were up to 12" long
- They were caught at night, except the week of the full moon each month of the season
- Skippers found sardines in the darkness by the green phosphorescence caused by the turbulence of the feeding schools of fish
- Sardine season was August 1st to February 15th
- An estimated billion sardines were taken from Monterey waters in an average season
- Two-thirds of the sardines landed at Monterey never saw a can at all: they were ground, pressed for their oil, and baked into fishmeal

INCHES

Photo by J. M. Hawthorne, Los Angeles.

FIG. 25.

CALIFORNIA SARDINE

Sardina cœrulea[3]

Relationship: A true sardine, belonging to the herring family (Clupeidae), in which are also classed the herring and the shad.

Distinguishing Characters: The single, short dorsal fin near the middle of the back; the absence of scales on the head; the absence of a lateral line; the mouth opening at the tip of the head, neither jaw projecting; the gill cover having low raised ridges running obliquely downward; the breast and belly not being drawn to a sharp, saw-toothed edge, although the scales on the breast and belly have spines which can be felt when the finger is moved toward the head. **Color:** Dark green above with many small dark spots, shading into bright silvery on the sides and below; the green color having opalescent reflections, the silvery part iridescent; a series of round black spots of varying degrees of distinctness often extends backward under the scales. Attains a length of about 14 inches.

Distribution: From British Columbia southward into the Gulf of California, with largest California landings being made at Monterey, Los Angeles, San Francisco and San Diego. Occurs in schools or "shoals."

Fishing Season: Caught throughout the year with certain legal restrictions for different districts, with maximum landings in the fall and winter months.

Importance: The largest fishery in the State. Mostly canned; rather small amounts appear in the fresh fish markets and some are smoked, salted and pickled. Extensively used as bait, the young for live bait fishing.

Fishing Gear: Purse seines, and lampara or round haul nets.

[3] Hubbs (Calif. Acad. Sci. Proc., vol. 18, no. 11, p. 261–265, 1929) has indicated a new genus (*Sardinops*) for this fish, but for the purposes of this bulletin, the older, more familiar form is used.

Detail from the Bureau of Commercial Fisheries, Fish Bulletin No.28: *Handbook of Common Commercial and Game Fishes of California,* by Lionel A. Walford, 1931.

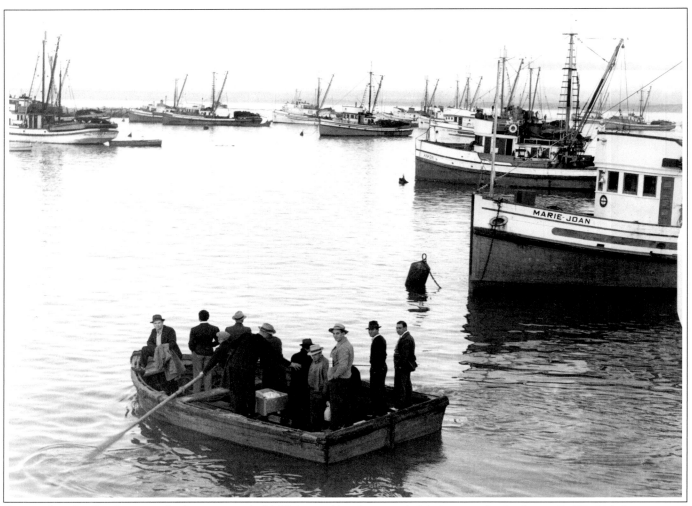

Crewmen dressed well as they set out for their seiners in the "skiff" that would anchor one end of the huge net when "set."　　　Fred Harbick [73-006-023]

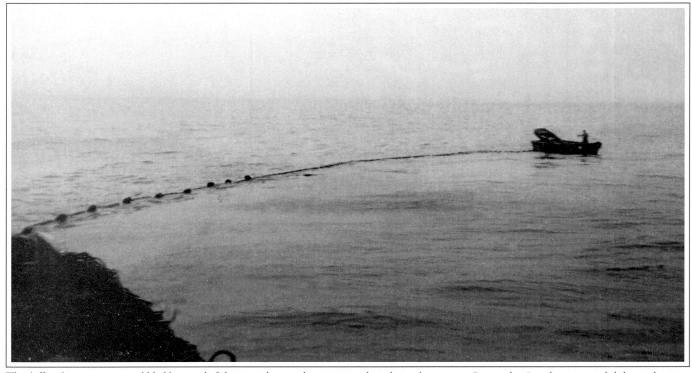

The skiff and its crewman would hold one end of the net with an underwater parachute device, known as a "sea anchor," as the seiner circled the catch to join the ends of the nets at the skiff, purse the net closed at the bottom and winch it in, stacking it on the seiner's revolving turntable.　　　[73-40-01]

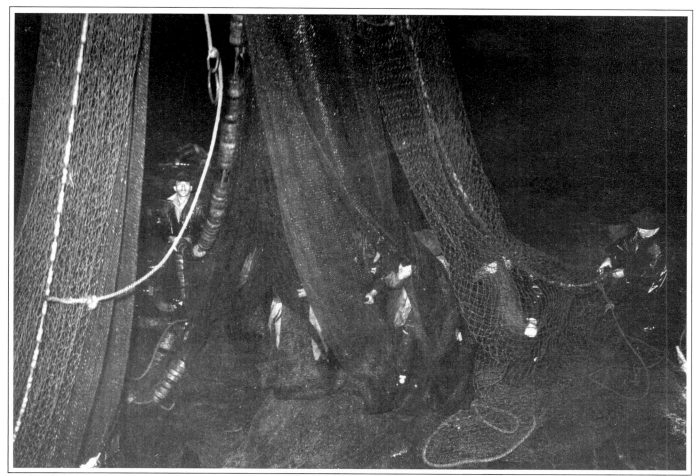

Work with the heavy, wet net in the darkness on a rocking boat was dangerous and exhausting work. The net is stacked on the turntable, which can then be rotated for redeployment and the "set" process is ready to begin all over again.

George Robinson photo [81-021-014]

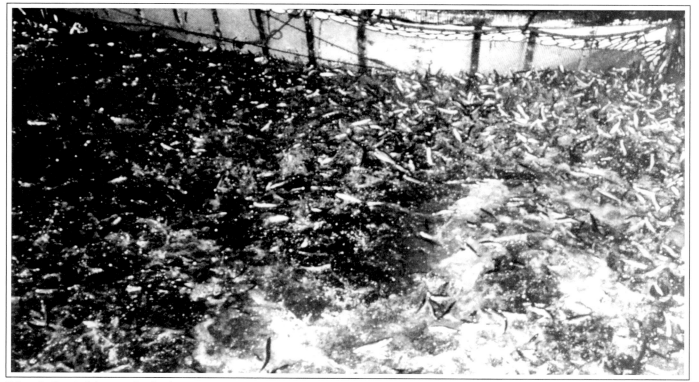

When the "bag" of the net is finally drawn up next to the seiner, the fish are held for brailing into the hold.

[77-19-04]

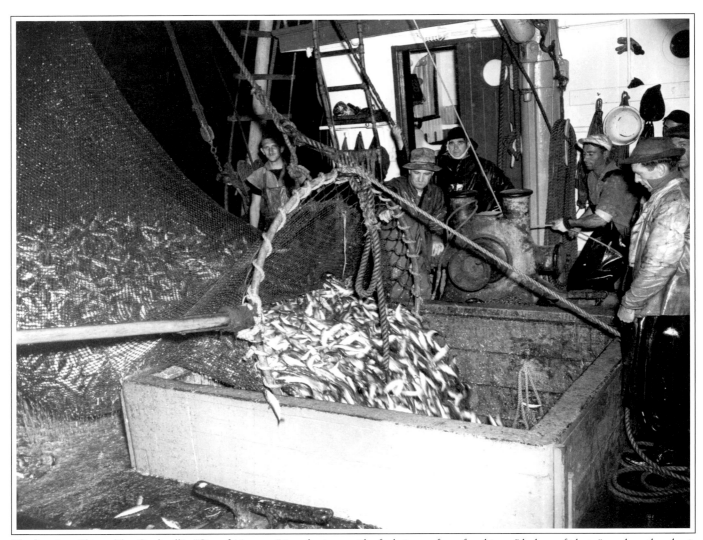

The dip net on Skipper Tom Cardinalli's "City of Monterey" is a classic example of what was often referred to as "the horn of plenty"--and another classic reminder of the size of the Monterey sardine. George Robinson photo [81-21-18]

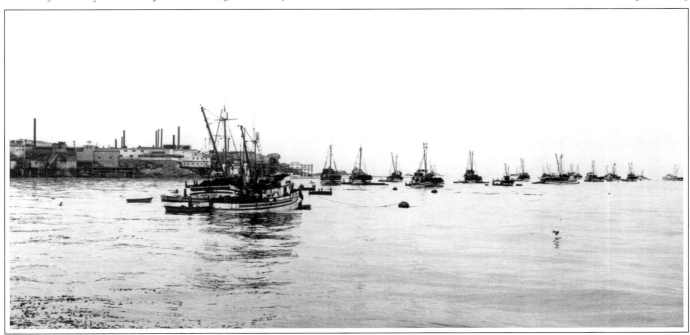

By dawn, the fleet is lined up at the cannery hoppers along Cannery Row to unload the night's catch. William L. Morgan photo [80-45-08]

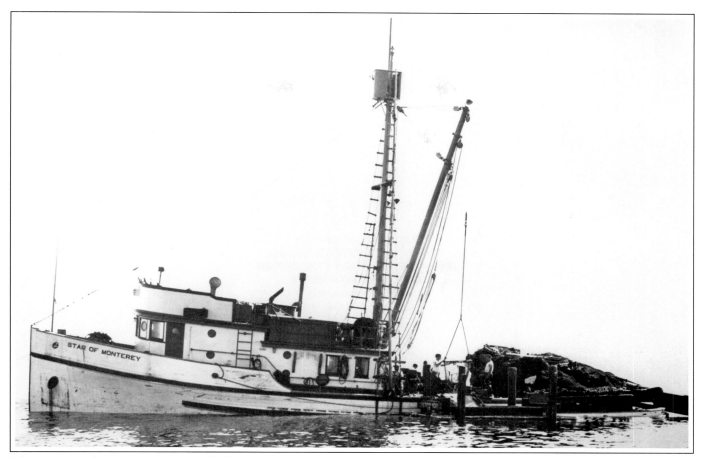

John Steinbeck aptly describes purse-seiners like Skipper John Russo's "Star of Monterey" so loaded with fish that they waddled into the Bay to off-load at the cannery hoppers. Riding this low meant a good catch and that meant a good pay day for crewmen that worked for shares, not by the hour. [80-45-3]

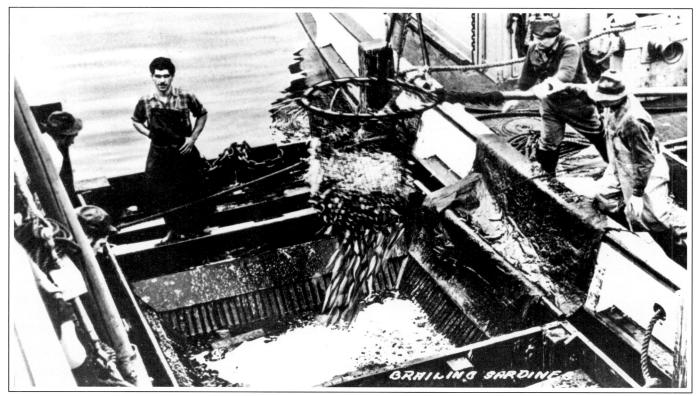

The old cable and bucket off-loading system was impossible to manage with the large size and catches of the purse seiners introduced in the late 1920s. Knut Hovden devised the slope-sided floating pens into which the seiner catch was brailed and then sucked by pump to the cannery. [79-111-03]

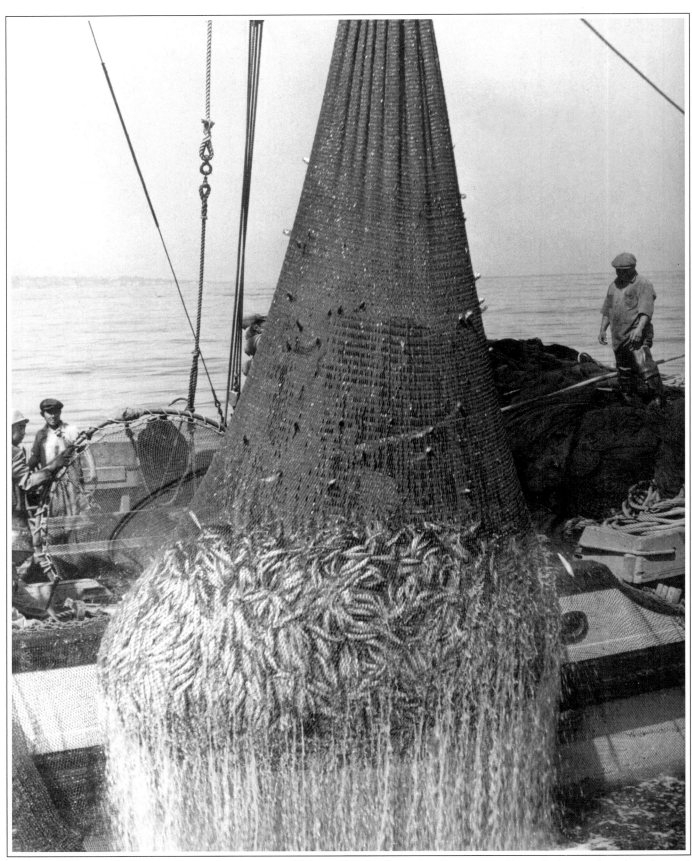

Occasionally catches exceeded the hold-capacity of the seiner and fish were shared with other friendly or partnered boats. Such a transfer is shown here with a Japanese crew guiding the "horn of plenty" to their hold.
Albert Campbell photo circa 1940 [77-009-008]

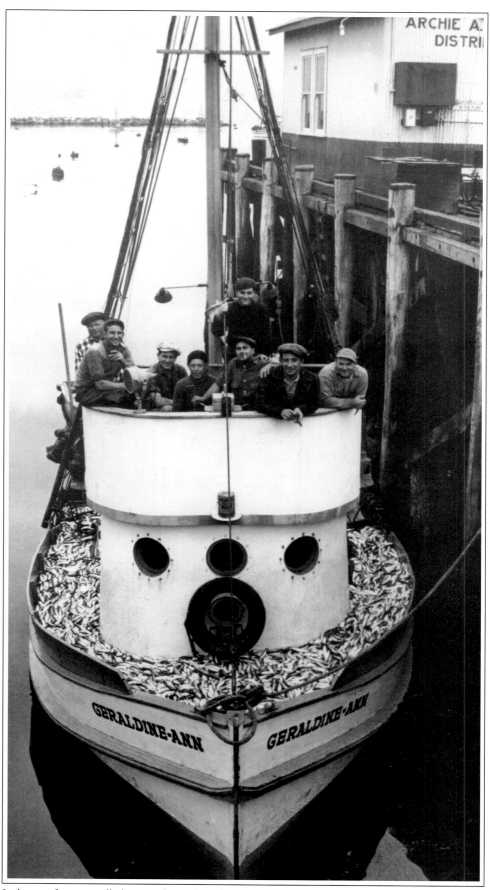

In the case of exceptionally large catches too large for the hold, it was common to pour the excess fish on the boat's walkways in a "deck load," as on Pete Cardinale's "Geraldine-Ann." [80-057-001]

The end of World War I, and its ensuing recession, saw a scramble for survival by the sardine factories along Cannery Row. The addition of new canneries contributed to the constantly changing face of the street as well.

Frank Raiter's San Xavier cannery opened at the north end of the Murray estate in 1917; Bernard Senderman, former partner in Pacific Fish Company, preferred retirement to further risk at his newly completed cannery, selling to local investors who opened it as Carmel Canning Company in January, 1920; the Japanese venture at Great Western Sardine Company becomes Sea Pride Packers; Pacific Fish Company sold to California Packing Corporation (Del Monte) in March, 1926; the American Can Company began construction on a huge can making plant across the Pacific Grove line in July, 1926; the San Carlos Cannery, opened by Angelo Lucido in 1927, was owned by boat owners and fishermen; Bayside Fish and Flour became Cypress Canning Company briefly in 1927 before becoming Ed David's Del Mar Canning Company; Old Custom House Packing Corporation, formed in April, 1929, joined at the shoulders with Carmel Canning at Hoffman Avenue and Ocean View Avenue.

What they all had in common was the processing of fish, and without great variation their geometry and layout were uncannily similar: the off-loading, weighing, cutting, packing, and cooking of the sardines were conducted on the ocean-side of the street. Straddling Ocean View Avenue to connect production to the cannery's warehouses were the crossovers--or bridges--by which canned sardines were transported across the street for storage, labeling and shipment from the Southern Pacific tracks at their back doors.

Each of the steps in processing was also roughly the same; the efficiency of the process often determined its fate. Monterey sardines were typically "French fried" in peanut oil prior to 1911, when steam cooking was introduced. By the end of World War I, the industry was mechanized to produce sardines pre-cooked in steam, mechanically sealed in their cans, and pressure cooked in them to complete the process. This was nothing less than a revolution in industrial time.

Changing fortunes in a later time: the Æneas Sardine Products Company being built in 1945, just before the crash. George Seideneck [72-12-049]

The San Carlos Cannery was initially owned by boat owners and fishermen, headed by of Angelo Lucido. One of the barons of Cannery Row, Lucido sponsored many immigrating countrymen and utilized thier talent and labor to become a major force in the industry. A. C. Heidrick [81-25-002]

ABOUT THE ABALONE

Monterey restaurateur, Pop Ernest Doelter, changed abalone history when he introduced his Monterey specialty-- abalone steak--to the world at the Panama Pacific Exposition at San Francisco in 1915. It sealed the future and the price of abalone forever.

His restaurant, "Pop Ernest's," was located at the entrance to Fisherman's Wharf. It introduced the mollusk to the palates of generations willing now to pay a ransom for what was then merely an unusual, formerly Oriental, delicacy.

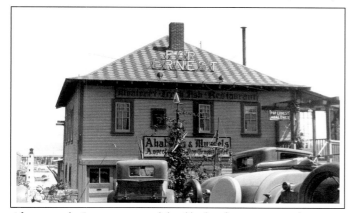

After 1915, the Japanese were prohibited by law from canning and exporting abalone. Fresh abalone steak became the mainstay of a stricken industry until Point Lobos based abalone diving ceased operation in 1932 to become a state park. Pop Ernest's closed in 1935. [74-006-013]

Pop Ernest Doelter. His promotional skills established abalone as a new and fashionable delicacy, especially after 1919, when he moved his restaurant from downtown on Alvarado Street, to Monterey to Fisherman's Wharf.
Rey Ruppel [82-031-07]

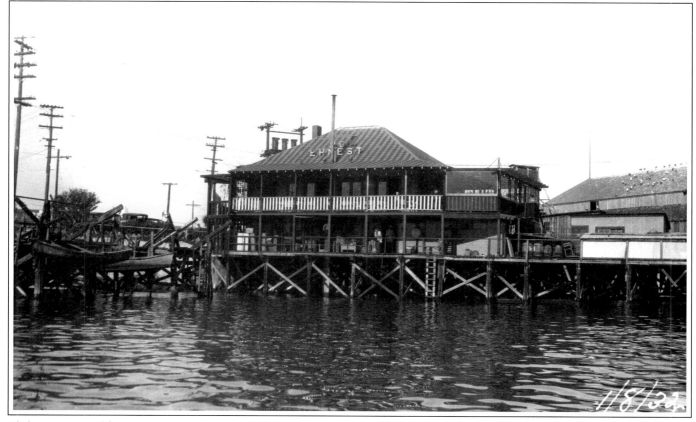

Abalone, once canned for export by the Japanese at Point Lobos, became a signature Monterey seafood at "Pop Ernest's." [83-04-01]

THE CANNING PROCESS

Boilermen brought the canneries to life before dawn, firing the huge boilers that would cook the fish and — prior to electrification — provided power to gear drives, link-chain and belt-and-pulley drive equipment throughout the cannery. It was the boilerman who routinely whistled the cannery workers awake to begin their day's toil at the packing tables and canning equipment. Each cannery had its own distinct whistle pitch and blast pattern to call its workers to the lines in an age before telephones in the working class home.

Fish unloaded at the hoppers were pumped ashore by the large turbines in the cannery's pump-house. The fish were then moved by escalator high up into the canneries for California Department of Fish & Game inspection and weighing. Gravity and hydraulic flows were used to move the processing of the fish along wherever possible.

Cutting that had been traditionally done manually by Chinese and Japanese and Spanish workers gradually became less specialized by nationality after the introduction of machine cutters. Slotted conveyors in which the sardines were placed were drawn under spinning blades that cut off the heads and tails and automatically eviscerated the fish.

The next stop on the trip to the can was at the packing tables, another conveyor system that moved the cut and prepared fish down a packing line. The famous one-pound oval can — the trademark of Monterey's sardine packing industry — was a curious holdover from the industry's salmon packing origins. Frank Booth, in his early sardine canning experiments, found that five or six Monterey pilchards fit neatly into the oval can. The salmon had passed into the lore of Monterey's early fish packing years, but left this unique memento of its one-time precedence: it was for this can that the young Knut Hovden invented the first machine solderer-sealer for Frank Booth.

Cans for the packing lines were often fed down track-like chutes from the floors above to await mating with lids at the sealing machines. Packed cans, depending on the cannery process, might be pre-cooked open before being inverted by machines designed to drain them before sealing. The last step on the way to the sealing machines was usually the addition of tomato sauce, mustard sauce, olive oil or other special seasonings.

Sealed cans of sardines filled large rolling steel retort baskets, which were then loaded into huge retorts (pressure cookers) to cook for about an hour and a half at approximately fifteen pounds pressure. "The Chef was a boilerman in overalls, watching and regulating steam pressure and temperatures in the retorts.

Cooling rooms were often provided for the hot cans, often waiting overnight in their retort baskets before they could be sent across the street in the cross-overs to be labeled and fed to "can catchers" for casing up and storage in the warehouses. Each warehouse had box makers who fabricated the cases used by the men catching and casing up the cans.

Often cans were cased for storage unlabeled, awaiting the particular order for which they would be labeled. Finally they were loaded into freight cars for the trip down the Southern Pacific tracks to Castroville to the main line and the world.

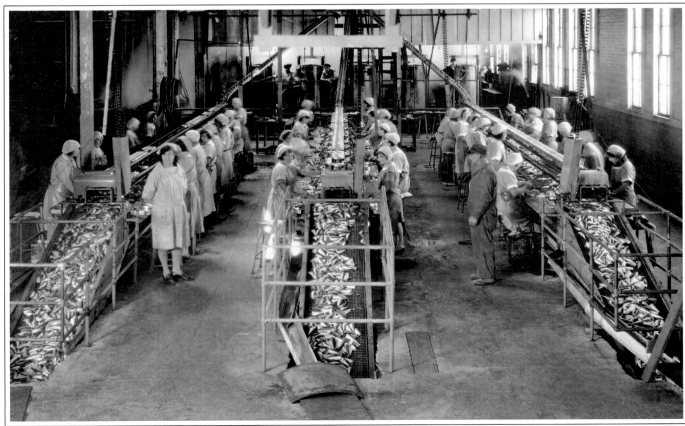

Thrity-six "American women" at the three double-packing tables at Hovden's. Typical photo; typical promotional commentary. A. C. Hiedrick [2002-049-1]

68

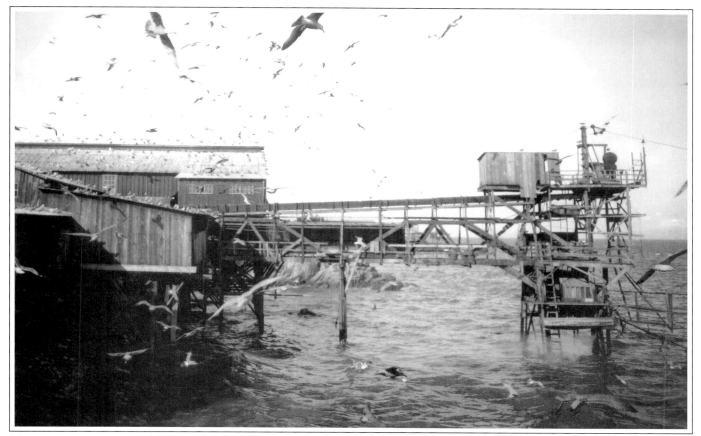

The canning process begins with bringing the fish ashore, in the early day's by cable and bucket. A. C. Heidrick [2002-049-02]

Following Hovden's innovative lead in 1927, canneries adopted floating hoppers in the early 1930s to offload purse-seiners by pumping the fish ashore from the hoppers through underwater pipes and hoses, laid, repaired and maintained each season by hard hat divers. Donn Clickard [81-011-030]

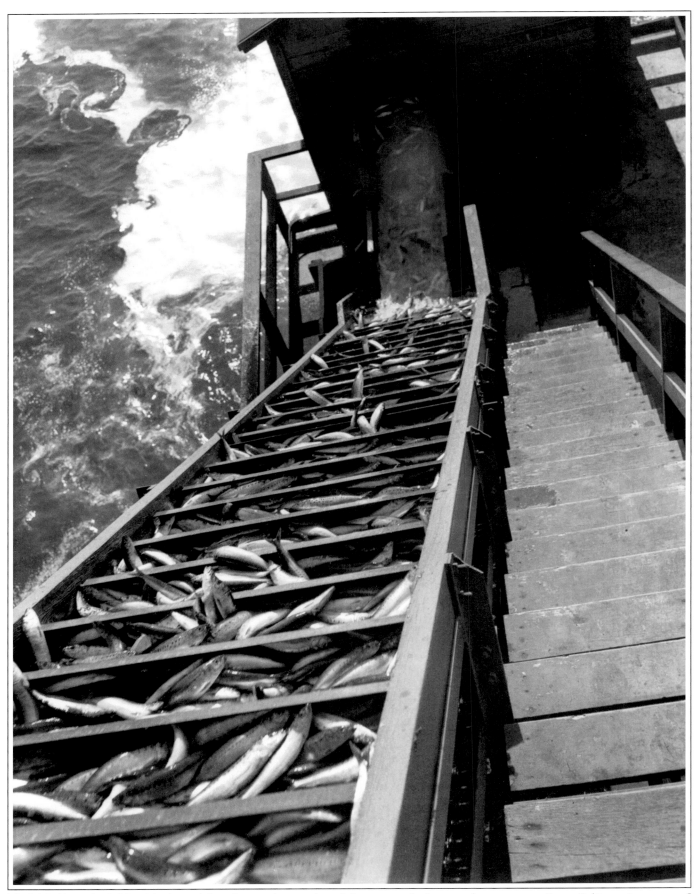

The fish ladder at the Cal-Pac lifts the catch from the pump house to the scale house, a standard cannery feature. *George Robinson* [81-021-022]

Canneries had a variety of scales to weigh the incoming boatloads of fish. A standard scale is shown here with a fisherman checking weights. [86-083-01]

Inspection could sometimes combine with weighing on the conveyor scales that weighed the catch on the conveyor. Rey Ruppel [80-045-05]

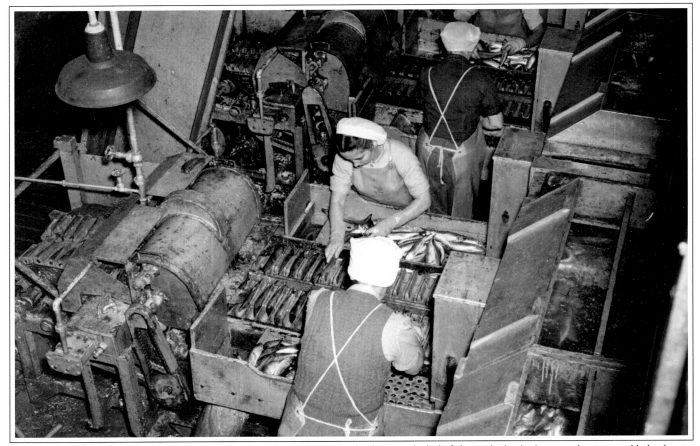

Expert, piecework hand cutting was eventually replaced by short conveyors with "slots" in which the fish were laid to be drawn under spinning blades that cut and automatically eviscerated the fish. Marilyn Monroe's first co-starring role was as a fishcutter on a machine like this in RKO's 1951 classic love triangle, "Clash By Night." There were lines of these machines in each cannery like these at Cal-Pac. George Robinson [81-021-027]

The cutting machines utilized less skilled, and less expensive labor to cut fish for the packing tables. Fred W. Harbick [72-20-04]

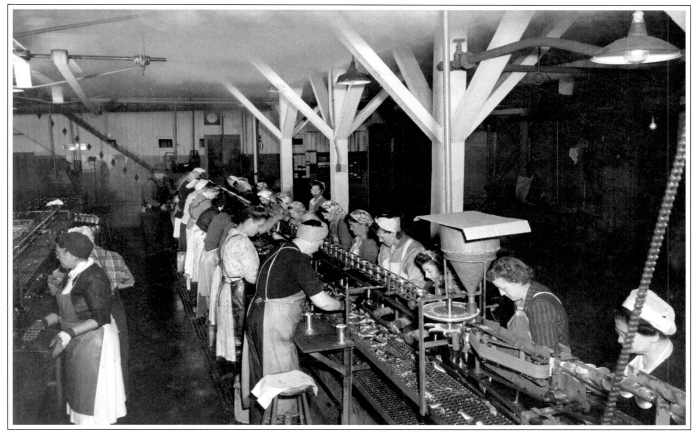

One-pound "talls" were also often packed in parallel lines with those packing the 15 oz. "One Pound Ovals." Fred Harbick [73-006-07]

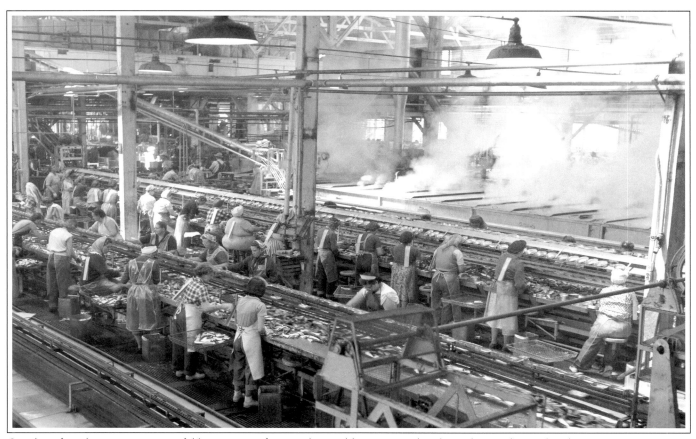

Can chutes from the upstairs can room, fed by cross-overs from warehouses, deliver one-pound oval cans down to these packing lines. [81-041-0011]

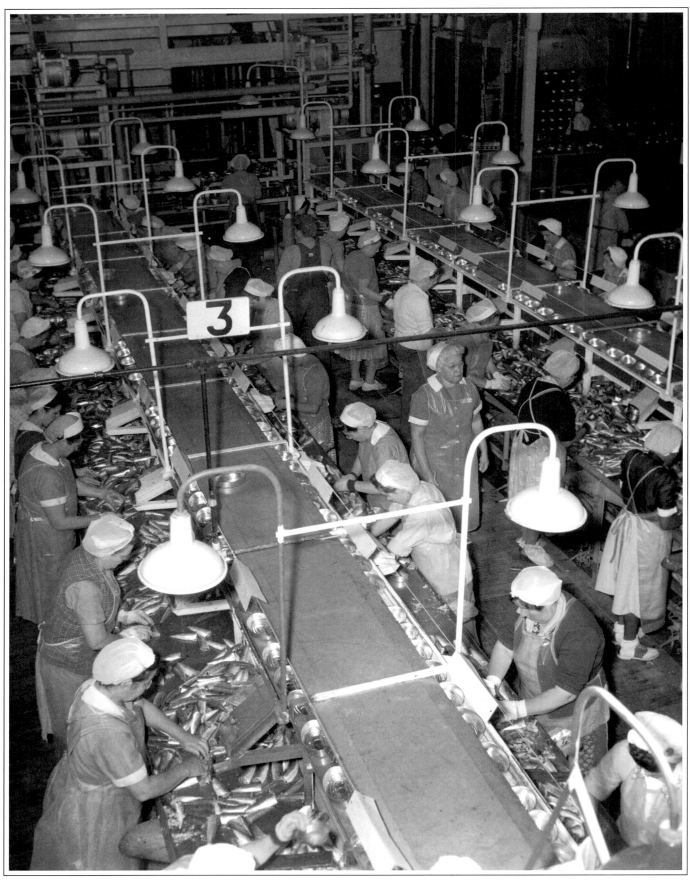

Packing a world-famous trademerk of Cannery Row--the one pound oval--at California Packing ("Cal-Pac") Plant 101. This was the same salmon can for which Knut Hovden invented the sealing machine, enabling the explosive expansion of the Monterey sardine industry. George Robinson [81-021-029]

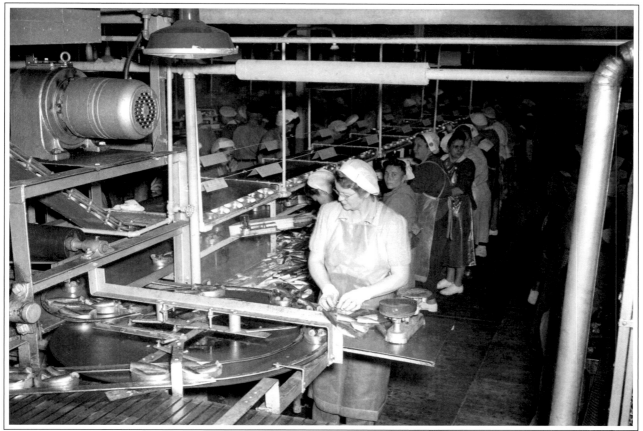

At the end of the line was a skilled "re-packer" to fill oddly packed cans or repack spilled ones prior to sealing. George Robinson [81-021-31]

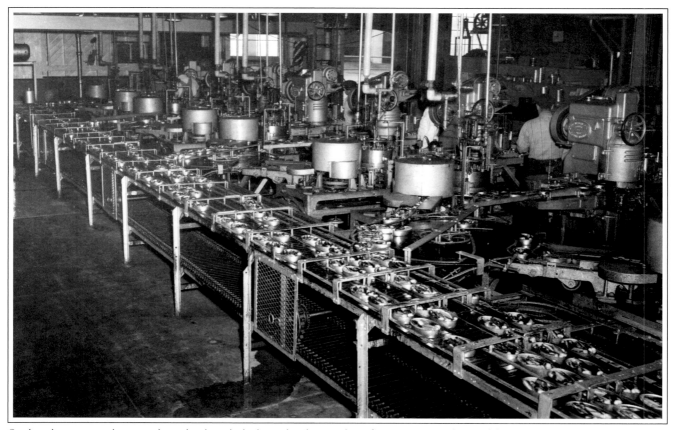

Good mechanics were always in demand to keep the high-speed sealing machines functioning properly. Breakdowns were an expensive nemesis to the orderly and profitable flow of fish through the canneries.
George Robinson photo [81-021-30]

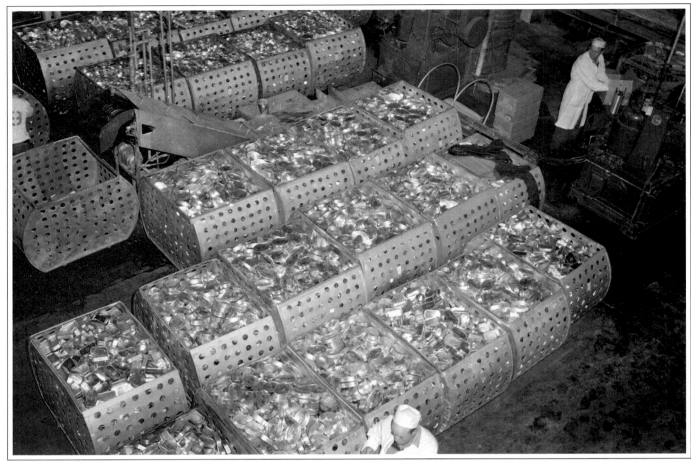

Sealed cans of sardines were loaded into large rolling bins called "retort baskets," which were wheeled to the cookers where the sardines were literally cooked in their cans. This is a look at the floor at West-Gate Sun Harbor (the old Del Mar Cannery). Donn I. Clickard [81-041-09]

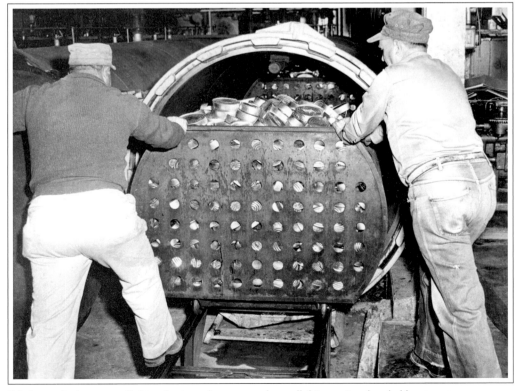

Filled retort baskets were rolled into horizontal pressure cookers called "retorts" and cooked by steam pressure.

[74-012-09]

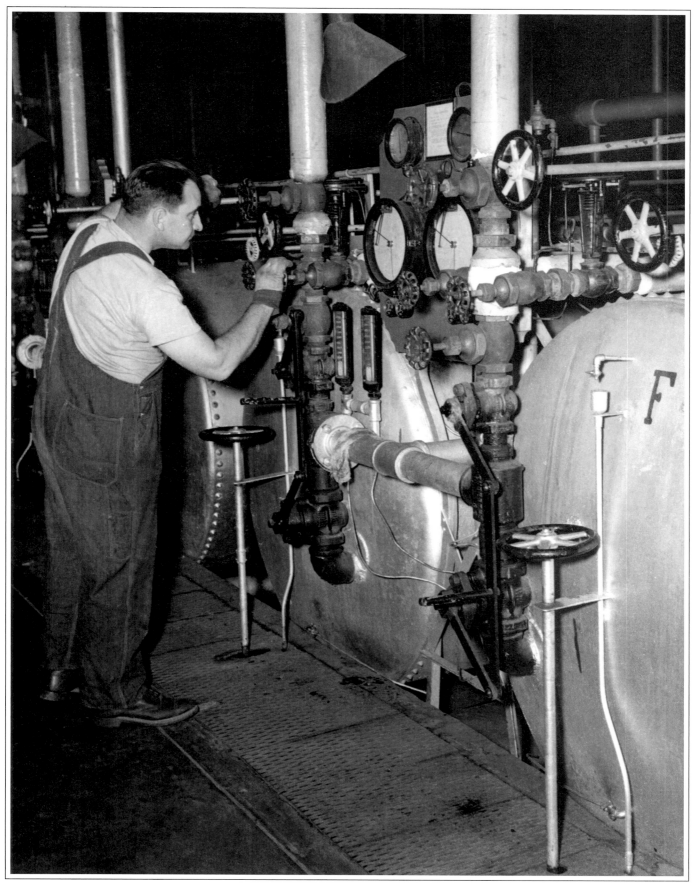

"The Chef" in the sardine cooking process was in reality a boilerman who carefully monitored temperature and steam pressure gauges as the sardines, often packed in tomato or mustard sauce, cooked in their cans.

George Robinson photo [81-021-033]

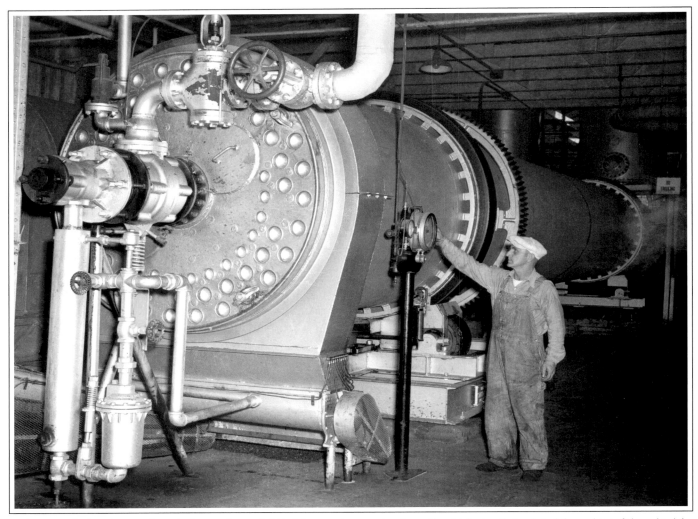

Each cannery had a reduction plant which ground tons of edible fish into pulp, pressed and centrifuged it for its oil, then baked the mash into fish meal in kilns like the one shown above. Large plants had several.

George Robinson photo [81-21-34]

The post-war era after World War I posed problems old and new. Without wartime demand, and the resumption of the Atlantic sardine fishery, foreign markets for Monterey sardines declined toward their pre-war status, as did the domestic market. Unfavorable tariffs simply compounded perhaps the biggest problem: canner's speculation had resulted in warehouses full of sardines. Something to prop-up the industry was urgently needed as canneries sold, closed or went bankrupt, .

Reduction and its huge profits on minimal investment and labor costs could no longer be ignored as a major part of the canning industry. The industry entered the 1920s with an ever-increasing pressure for legislation to permit larger scale reduction and by-product use of the catch. Warnings by the state's Department of Fish and Game specialists were pitted against industry survival: reduction profits would subsidize the depressed canning industry. The decade of the twenties was to establish this irreversible direction of the industry to profit at the uncertain expense of the fishery. Besides, as Hovden would state, "The sardine supply could not be exterminated"— at a time when certain proof could not be produced to the contrary. The decade of the thirties would test that assumption.

The reduction process was relatively simple and required modest investment and labor to operate. It did recover and make nearly complete use of vast amounts of fish processing waste, but it was also to blame for the stomach wrenching smell incorrectly blamed on canning of sardines. It was an impetus that irrevocably pointed the industry toward suicide. Grinding of offal (the fish heads, tails and entrails) from the canning process was suddenly augmented by the increasing tonnage of whole, otherwise edible fish. The industry's increasingly powerful industrial legislative lobby saw these otherwise canable sardines ground into pulp and cooked in screw-cookers before being squeezed or centrifuged of liquid content. The remaining pulp, or "cake," was baked in rotary kilns and ground into fish meal. The liquid pressed and centrifuged from the pulp was reduced by further cooking to a heavy consistency that sold as a poultry feed additive or was added back into the manufacture of "whole" meal fertilizer. Another result was Monterey's famously fouled air.

Because the manufacture of fish meal, fertilizer, and other by-products was far simpler and also more profitable than sardine canning, the packing of sardines was ultimately to become a sideline for the reduction and by-product manufacturing process: Monterey's canning industry had become, primarily, a fish meal and fertilizer industry.

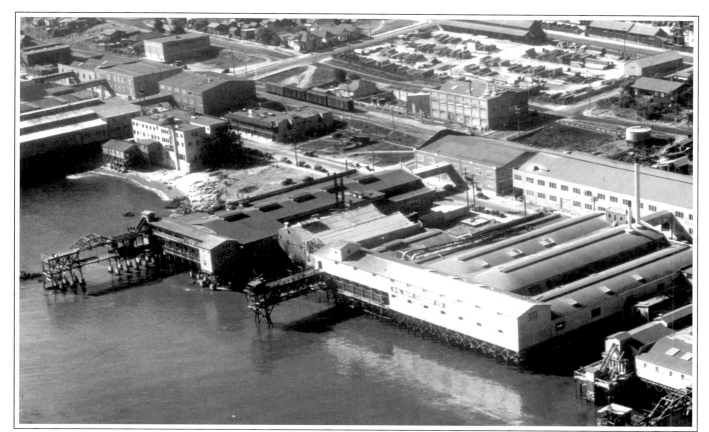

With the vast majority of industrial production done on the ocean-side of Ocean View Avenue, the completed products were moved to the warehouse side by overhead "cross-overs" that enclosed conveyors and pipelines for fish oil. Some also enlcosed large pipes through which fish meal was blown across the street to warehouses for grinding and sacking prior to shipment by rail from the rear of the canneries. Ted McKay photo [84-096-01]

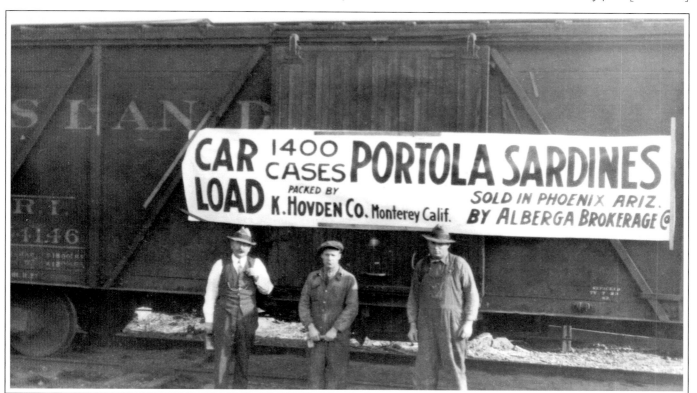

Charles Crocker's Southern Pacific Railroad brought tourists and Monterey's emigrating workforce to the Central Coast. Monterey's sardines departed on the same rails as cases of ovals and talls, 100 lb. sacks of fishmeal, and 5 gallon cans and tank cars of sardine oil. [81-39-1]

Can-catching and casing-up of cooked cans, box making, labeling and storage were the realm of the warehouse. Fred Harbick [73-006-018]

In fishmeal warehouses, meal blown from the cannery was sacked and stored until loaded in boxcars or trucked to ships. Fred Harbick [73-006-019]

A look at a typical warehouse crew on the Row in 1936--this one at the Hovden boxcar loading dock.. Courtesy Charles Nonella [86-061-001]

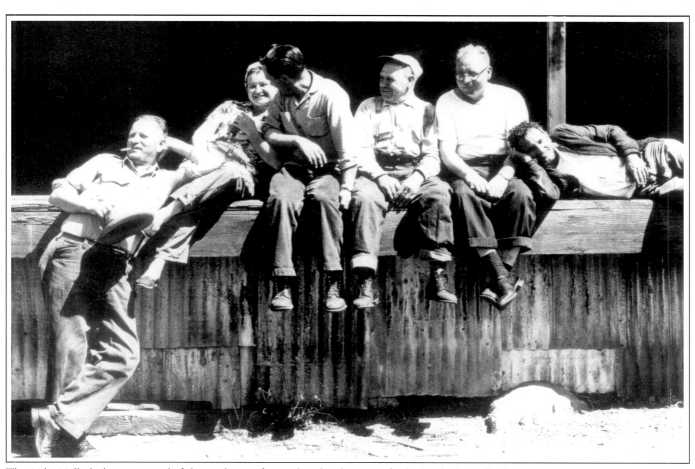

This Miles Midlock photo captures the feeling and spirit of its workers that the genius of John Steinbeck translated into "Cannery Row." [81-051-02]

The early "floater" in this William L. Morgan photo may be the "Brookdale"--first floating reduction plant in a fleet of reduction ships to operate off the California Coast in the 1930s. Their dramatic impact on the volume of sardines already diverted to fishmeal and fertilizer helped tip the balance of the survival of the Monterey sardine. It appears that too many mature sardines were taken to sustain reproduction levels and size of the fish. [89-072-011]

Warnings against the potential depletion of the sardine began in the early 1920s, before the wholesale reduction of sardines--the grinding, pressing, and baking of sardines into fishmeal and fertilizer--came to account for the vast majority of fish tonnage landed and processed not only in Monterey, but on the entire West Coast in the 1930s. The first official biological warning of the possibility of depletion came in 1921 and was met with apathy and disregard. This warning came at time before the enormous volume of fish delivered directly for reduction to the floaters off the coast in the decade of the 1930s as shown in the detail from Table 8, on page 83.

The Great Depression made partners of business and labor to exploit the fishery on the unlikely prospect, in their view, that real damage could be done the sardine stock.

Max M. Shaeffer's aggressive early leadership into land-based reduction as a discreet industry operating in parallel with canning fish, was mirrored in the 1930s by Stanley Hiller of Santa Cruz, who would lead the industry into avoiding state limits on reduction by processesing unlimited amounts of sardines delivered to floaters directly by purse seiner beyond California's 3-mile legal jurisdiction. Hiller was already a major supplier of reduction equipment to canneries on shore and took a major role in fitting out frieghters for use as sea-going reduction plants.

The Great Depression was still a dominant force in the pressure to keep the canneries operating and employment at maximum possible levels--even if such policies threatened the sardine supply. The addition of the fleet of unrestricted floaters to the relaxed limits for on-shore reduction facilities had consequences that were projected by fisheries biologists. With an sustainable yield of 250,000 to 300,00 tons per season estimated by fisheries biologists, the annual take by the industry was two to three times as much. The resulting loss of such a volume of mature sardine breeding stock had a highly dramatic effect on reproduction in the succeeding seasons.

It is now widely agreed that the pressure on the bio-mass due to the addition of the floaters to the already excessive diversion of fish into reduction by on-shore plants was a blow from which the sardine stock never recovered.

Reproduction levels faltered in the following years, masked in part by the increasing efficiency of the new purse seine technology. In spite of factoring in temperature changes, currents, and other effects on the fishery, the failure to have reserved a critical level of mature breeding stock that could survive those pressures was an error once comitted could not be reversed.

The failure of the spawing seasons of 1949 and 1950 are blamed for the final collapse of the fishery--a species "crash" being repeated all over the globe at this very moment.

TABLE 8
SEASONAL LANDINGS IN TONS
Sardines

Season*	Reduction ships	San Francisco area	Monterey area	Los Angeles area	San Diego area	Total tons
1926–27	----	3,520	81,860	64,720	2,110	152,210
1927–28	----	16,690	98,020	67,900	4,650	187,260
1928–29	----	13,520	120,290	119,250	1,420	254,480
1929–30	----	21,960	160,050	140,540	2,620	325,170
1930–31	10,960	25,970	109,620	38,490	80	185,120
1931–32	31,040	21,607	69,078	42,656	264	164,645
1932–33	58,790	18,634	89,599	83,605	62	250,690
1933–34	67,820	36,336	152,480	125,047	1,746	383,429
1934–35	112,040	68,477	230,854	178,818	4,865	595,054
1935–36	150,830	76,147	184,470	138,400	10,651	560,498
1936–37	235,610	141,099	206,706	138,115	4,594	726,124
1937–38	67,580	133,718	104,936	109,947	383	416,564
1938–39	43,890	201,200	180,994	146,403	2,800	575,287
1939–40	----	212,453	227,874	96,827	112	537,266
1940–41	----	118,092	165,698	175,592	1,202	460,584

Detail from the Department of Fish and Game, Fish Bulletin No. 149: *The California Marine Fish Catch for 1968 and Historical Review 1916-1968*, by Richard F. G. Heimann and John G. Carlisle, Jr., 1970. The full table can be found on page 102.

It is not just a little ironic that the sardines are back. It is known their appearance along the West Coast is a cyclical phenomenon--proven from scale counts in the ocean sediment indicating numbers of fish perhaps twice as large as their presence during the rise and fall of old Cannery Row. A number of converging factors sped their disappearance in the last century. Over fishing, reduction, as well as ocean temperature fluctuations and current changes affected the distribution and reproduction rates for the species. The "even so" statement still holds, however, that we did irreparable damage to our own livelihoods and lifetimes in the conduct of the fishing and canning industry at Monterey. The carelessness, greed, indifference and arrogance of our record here in the management of an incredible natural resource that could have continued for many more generations is one the world has yet to learn. Monterey, in the 1930s and 1040s, had the opportunity to control its own destiny. Instead, politics permitted profit over the intelligent conservation of the resource--and the question of "fish or jobs?" was answered with "jobs." The result was the loss of the fish...and the jobs. This is an ecological equation that demands attention and consideration in virtually every sustainable resource management situation around the globe.

It was economics--especially The Great Depression--that created a willing collaboration between business and labor and government to subordinate the survival of the fishery to their own. The demand for fish meal and fertilizer as California agriculture expanded, and the floater excesses of the 1930s, ultimately spelled the early end of the Monterey sardine industry. It was simply a matter of time.

Loading a coastal freighter, the alternative to meal by rail. [97-31-05]

As the corrugated tin, plank, and stucco canyon of canneries that lined Ocean View Avenue grew in number and size, the cross-overs (covered conveyor and pipeline bridges) that vaulted the street also grew to transport supplies to the canning side of the street from the warehouse side. Those same bridges returned finished cans of sardines, oil--and in some cases, fish meal blown through pipes from reduction plants in the canneries on the ocean side of the street--back to their warehouses on the other.

Over the years there were a total of sixteen such cross-overs, or bridges, that combined to provide Cannery Row with its world-famous architectural feature, one that is employed in its contemporary commercial development.

Of the sixteen original cross-overs, two remain into the present day life of Cannery Row. The oldest is the Monterey Canning Company crossover, serving its World War I era cannery built by Scotsmen A. M. Allan and George Harper in 1918. That cross-over has been adapted to become a pedestrian bridge over the street.

The other original of the sixteen bridges is that of the ÆNEAS PACKING COMPANY, a late entry into the industry in 1945, just before the crash of the fishery. It is, at this time, unserviceable but restored and maintained as an authentic icon of the industry that made Monterey famous and forever linked to the rise and demise of the sardine. And now for a look a the street of sixteen bridges.

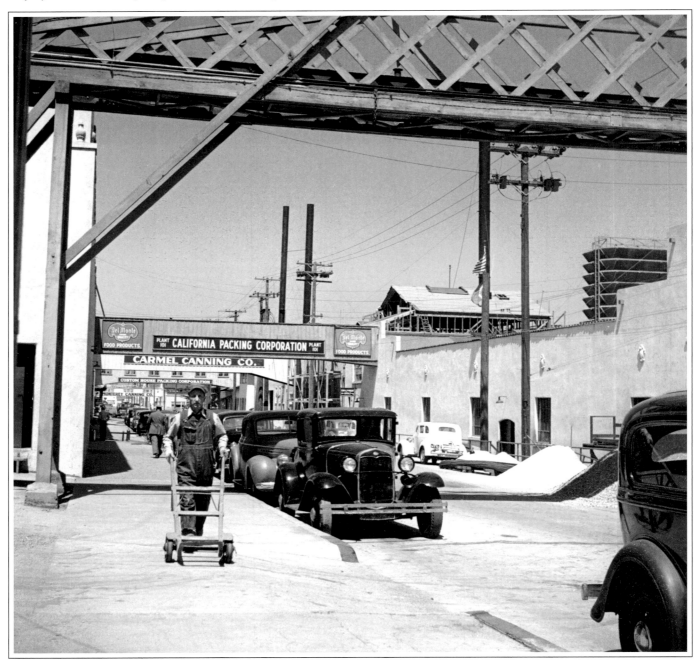

Cannery worker, Hank Damewood, in the icon Cannery Row photo by George Seideneck, 1945. Like cannery worker Harold Otis Bicknell, the model for John Steinbeck's Mack of "Mack and the boys," Hank Damewood never anticipated his accidental role in Cannery Row history. [72-012-053]

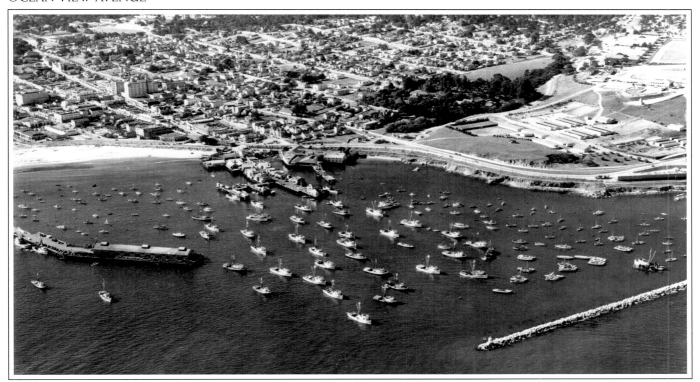

Monterey Harbor's Wharf #2, the fleet at Fisherman's Wharf, the F. E. Booth Cannery, and the Presidio of Monterey at "Lighthouse Curve." [83-06-018]

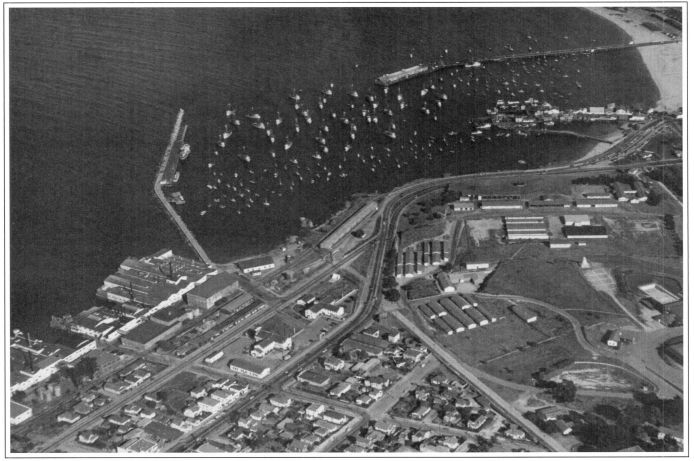

The photographic team of Kaldor-Bates provides this rare look at the Peninsula Packers and San Carlos canneries at the Monterey end of the Row, the harbor, complete with both wharves, the defunct Booth cannery's wharf and a look at a portion of the Presidio of Monterey, 1949. [87-23-03]

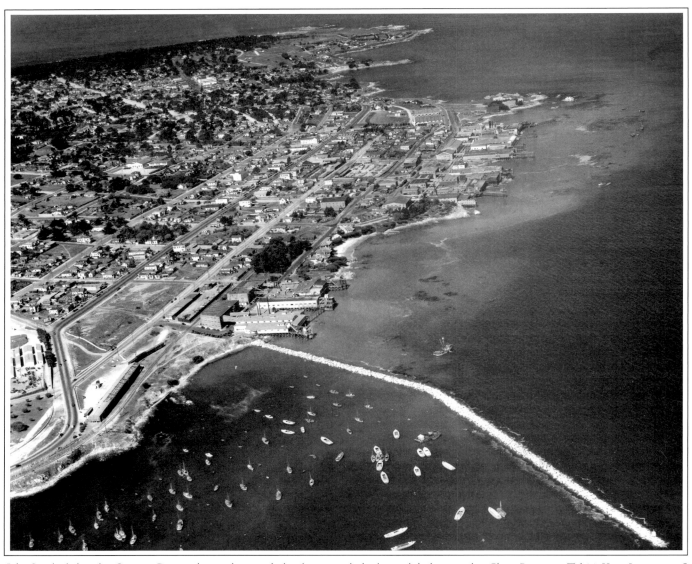

John Steinbeck describes Cannery Row as the area between the breakwater at the harbor and the boat yard at China Point. *Ted McKay* [83-06-025]

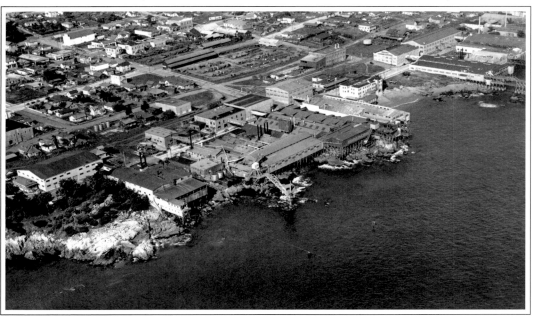

San Xavier, Cal-Pac, Carmel, Custom House, the Ocean View Hotel and McAbee Beach, Monterey, and Del Mar.
Ted McKay [80-45-06]

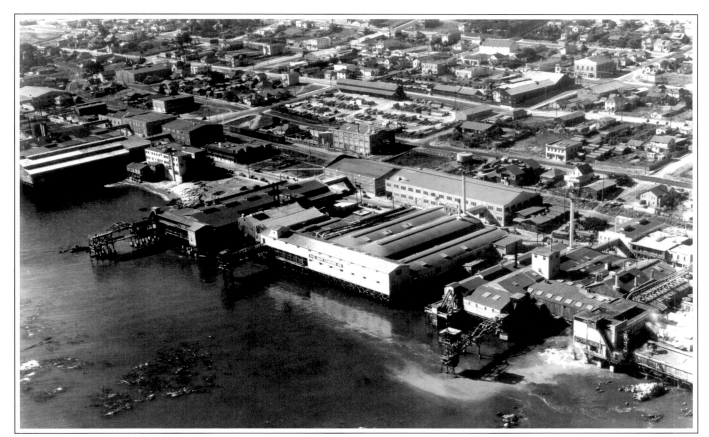

Custom House, McAbee Beach and the Wu hotel, Monterey Canning, Del Mar, Sea Pride and the Hovden. *TedMcKay* [84-96-001]

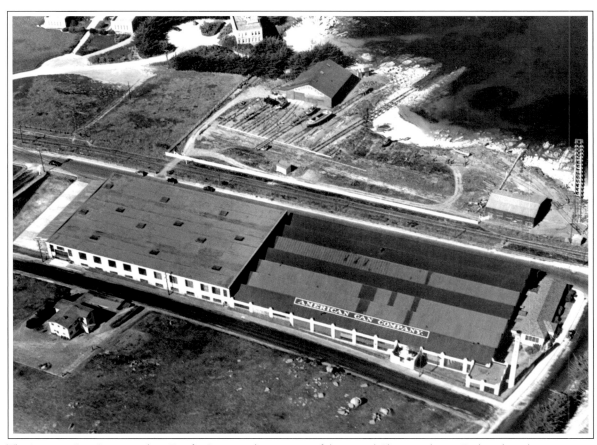

The American Can Company plant, Pacific Grove, on the upper part of the original Chinese settlement. Built in the mid-1920s, it rose to monopolize the can trade on the Row. *Ted McKay* [83-06-024]

John Steinbeck made Monterey's fish canning district world-famous by writing about the exploits of its real inhabitants. [81-21-95]

Marine biologist, Ed Ricketts, became John Steinbeck's closest friend, mentor and inspiration--and a number of his fictional literary characters. These roles did, however, obscure his major professional accomplishments. *Bryant Fitch photo {97-116-001}*

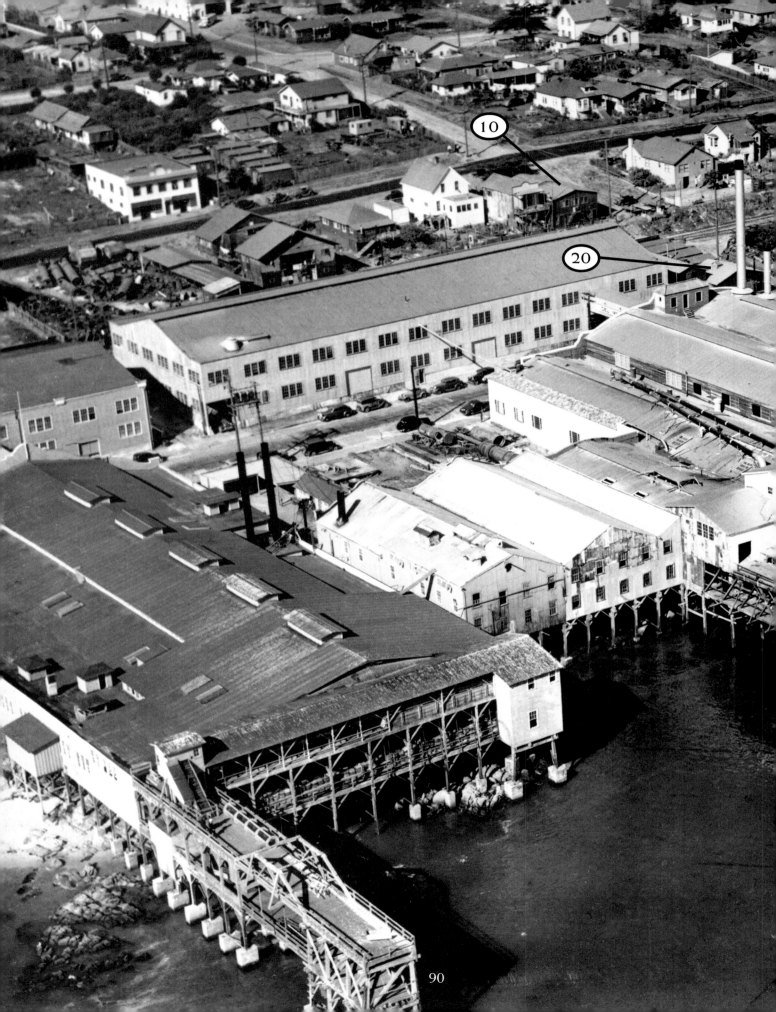

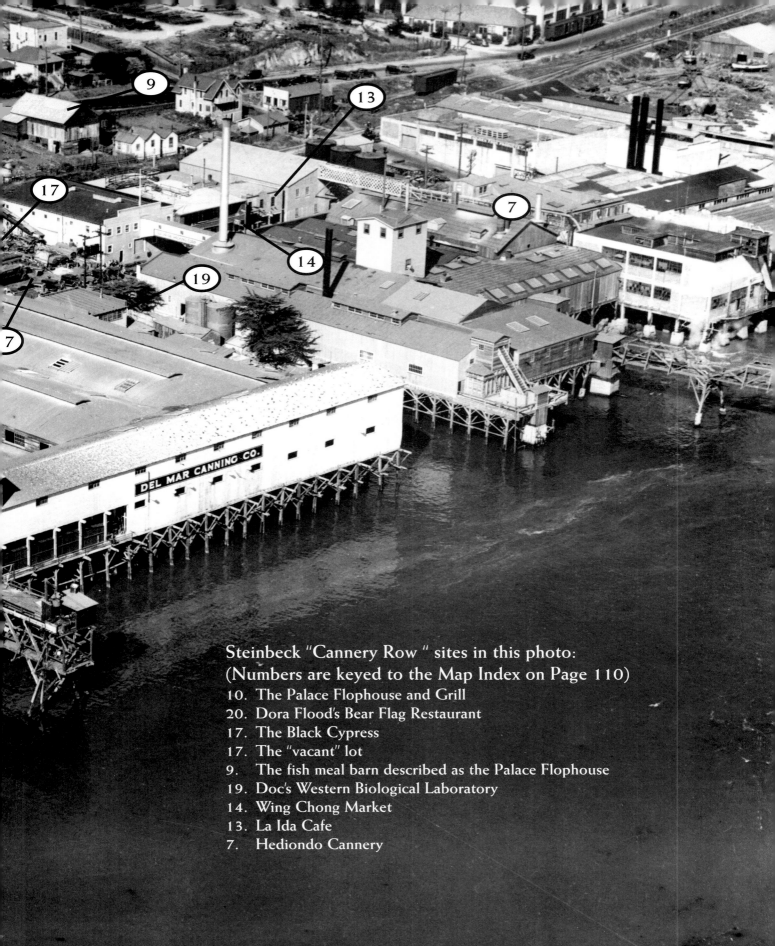

DEL MAR CANNING CO.

Steinbeck "Cannery Row " sites in this photo:
(Numbers are keyed to the Map Index on Page 110)
10. The Palace Flophouse and Grill
20. Dora Flood's Bear Flag Restaurant
17. The Black Cypress
17. The "vacant" lot
9. The fish meal barn described as the Palace Flophouse
19. Doc's Western Biological Laboratory
14. Wing Chong Market
13. La Ida Cafe
7. Hediondo Cannery

Ted McKay [83-06-062]

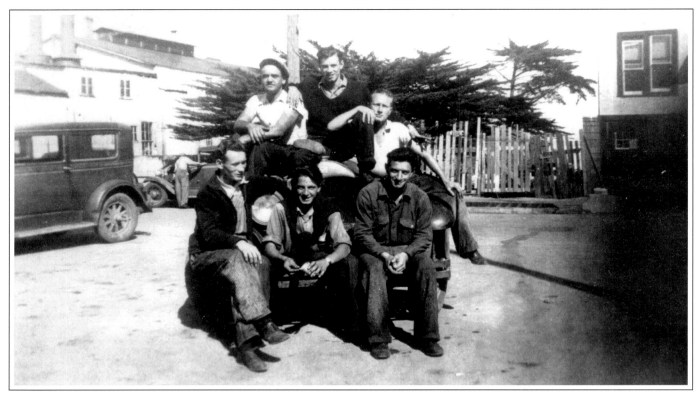

"Gabe" Bicknell (back row, left, in cap), John Steinbeck's model for Mack in "Cannery Row," with friends in front of the original 740 Ocean View Avenue Pacific Biological Laboratories, 1935. This structure burned to the ground when the Del Mar cannery next to it caught fire in 1936. [97-108-001]

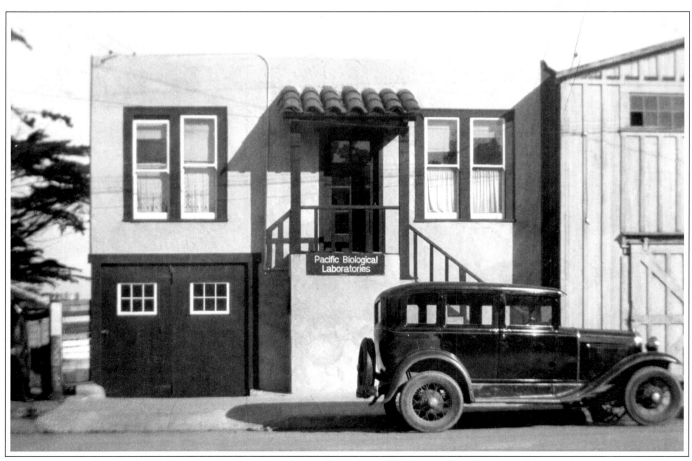

The lab was originally a single-story house purchased in 1928, the year Ricketts moved his biological supply business from Pacific Grove. It was lifted and the laboratory portion of the building constructed downstairs by Pacific Grove contractor, Roscoe Wright. Fred Strong photo [95-033-011]

Looking down Ocean View Avenue past Flora Woods' Lone Star Cafe, on the right-hand side of the street in this 1935 photo. [97-108-003]

Flora Woods, the magnanimous madam of Cannery Row shown in this 1944 photo, after her days in "the business" were over. [85-024-01]

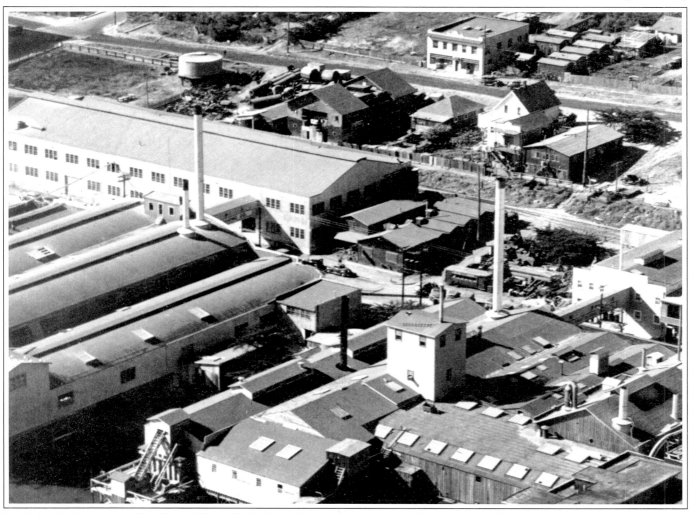

Ed's Lab with the Lone Star (Bear Flag) of Flora Woods (Dora Flood) across the street; the "vacant lot" and Black Cypress; uphill, above the tracks, the Palace Flophouse. [84-096-01]

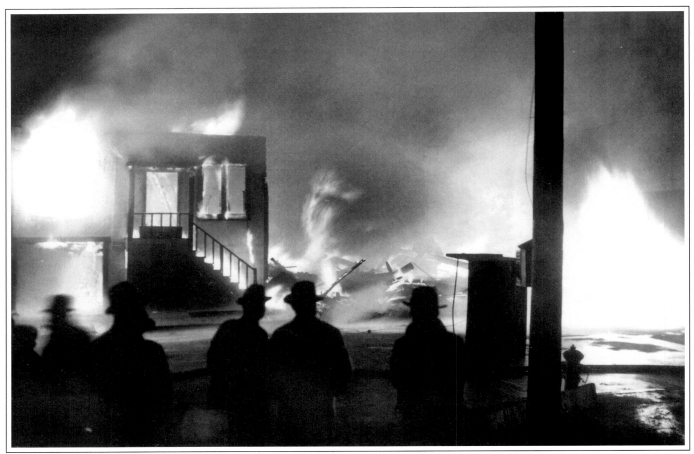

The Del Mar Canning Company caught fire on November 25, 1936, and the fire spread to destroy the Lab completely. [93-044-01]

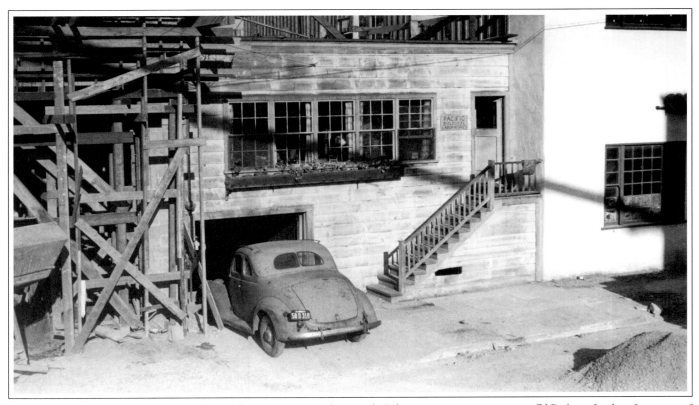

Del Vista Packing Company, a concrete reduction plant, was constructed next to the Lab in 1946. *Ed Ricketts, Jr. photo* [98-83-012]

Ed Ricketts' living room with its fold-down table and book shelves, in the rebuilt Lab. *1947 Photo by Ed Ricketts Jr. [81-021-071]*

Ed's hemp-rope suspended mattress and its Hudson Bay blanket, beneath a small copy of Elwood Graham's portrait of John after the trip to the Sea of Cortez. Ed kept it to cajole John, who was uneasy with the image. The simple furnishings of a Rennaisance man.

Ed Ricketts, Jr. [81-021-074]

Some of Ed Ricketts' laboratory glass and equipment used for preserving, identifying and preparing his specimens for sale. Fred Strong [95-33-05]

Ed's close friend, Richie Lovejoy, who was responsible for many of the scientific illustrations in Ed's "Between Pacific Tides," in the Lab with Ed and a ray.

[81-021-070]

The Del Monte Forest sloping to Carmel Beach; Carmel and its treeless Carmel Point; and Carmel River Beach. 1920s Russell Aero Photo. [81-06-26]

Another not-so-fictional locale from Steinbeck's "Cannery Row" is the area of the frog hunt in Carmel Valley. The Hatton Ranch is seen at the entrance to the valley on Carmel Valley Road at Highway 1. [72-03-062]

The Wing Chong Market of the Yee Family could not have been described more accurately than by John Stienbeck. George Robinson photo [81-21-88]

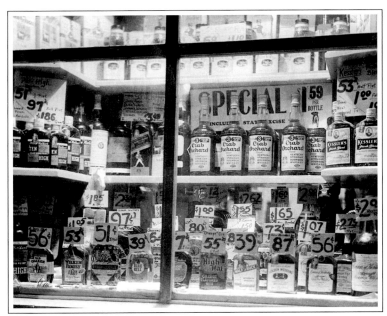

The elixirs of cannery life, like the "Old Tennis Shoes" of Steinbeck's only slightly fictional "Cannery Row." [2001-20-0121] 1947

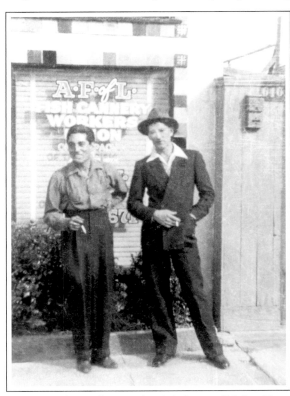

Cannery workers at the A. F. of L. Fish Cannery Workers Union office at the Ocean View Hotel. [85-029-01]

THERE IS NO "DOC RICKETTS"

The major defining point in John Steinbeck's "Cannery Row" is the focal character of "Doc." Around him, the rest of one of the greatest stories in American fiction is constructed and unfolds. John Steinbeck's official biographer, Professor Jackson Benson, assessed John's greatest works in this order: "Of Mice and Men"..."Grapes of Wrath"...and "Cannery Row."

Until that moment at the annual Steinbeck Festival in Salinas (at the release of his Steinbeck Biography in 1984) when he replied to a question as to what he, personally--as Steinbeck's official biographer--considered his most important works, little had been considered of the import of a relatively obscure and seemily lighthearted and nostalgic flashback on America at a simpler time. Its inclusion in Steinbeck's top three by Jack Benson shed new light and interest on a far more complex and sophisticated literary work than had been appreciated--at least until then.

John writes his editor, Pat Covici, at Viking Press that he has written it on four levels. Susan Shillinglaw of the Steinbeck Studies Center at San Jose State University has furthered that case with an introduction to the Penguin 1994 edition of "Cannery Row" in paperback--featuring on the cover, no less than Harold Otis "Gabe" Bicknell: John' self professed model for Mack in "Cannery Row."

But nowhere in "Cannery Row" is there a Doc Ricketts. Only a Doc. Ed was known and referred to by his friends as, simply, Ed. It is surely because the character of "Doc" was constructed so obviously on Ed Ricketts--even to the use of his real name in its dedication: "For Ed Ricketts, who knows why or should"--that over time the two would blur. But this mingling of the real and fictional roles of Ed Ricketts does create a significant point requiring comment and clarification.

Ed Ricketts was an accomplished marine biologist, without a degree after two years at the University of Chicago, but none the less an accute and systematic observer of the intertidal zones from which he collected his livelihood and his scientific status. He came to Pacific Grove in 1923 with a partner, Albert E. Galigher, to set up a biological supply business providing specimens to science classes, schools and laboratories all over the country. Without academic creden-tials, however, he was initially considered by the tenured at Hopkins Marine Station of Stanford University, as only slightly less than a poacher of the intertidal.

The decade of the 1930s, in the middle of the Great Depression, Ed Ricketts amassed the most complete intertidal record of the West Coast of North America in existence anywhere--at any university. All consolidated in a fitful biological supply business run from a small stucco home and laboratory squeezed between sardine factories in a canyon of canneries that lined Ocean View Avenue in Monterey.

Beyond his scientific interests, however, Ed displayed what Katie Rodger calls, "The Renaissance Man of Cannery Row" in her work of his collected letters. His interest in art, philosophy, classical music, poetry--particularly the Chinese of Li Po and the Tao--and his sincere touch with people of virtually all ages, made Ed the center of a certain universe on Cannery Row and around Monterey. This was the man John Steinbeck was introduced to at a party at Jack Calvin's cottage in Carmel in 1930. Neither would be the same again.

Ed Ricketts in the Lab, circa 1936, by Bryant Fitch. [81-021-078]

The symbiotic relationship between writer and scientist is not as simple a dichotomy as might be thought. John Steinbeck had shown a facility and interest in science and biology well before his intermittent and turbulent Stanford years. He professed that had writing not worked out for him, he may have joined his friend and mentor, Ed Ricketts, in the biological supply business. John was, in fact, a capable amateur biologist by any measure--one good enough to contribute effectively to the Sea of Cortez mission.

Ed, on the other hand, admired John enormously for his skill and command of the crafted word. Ed's scientific and philosophic composition suffered from a stilted and tortured expression too frequent among scientists. Yet his concepts were revolutionary and he was committed to their expression.

Ed's manual of the West Coast intertidal zone was published in 1939 by Stanford University Press, with help from John Steinbeck. It is a tribute to Ed that generations of senior marine biologists gladly admit that it was Ed Ricketts and his landmark work, "Between Pacific Tides," that inspired them into the field. The manuscript for Ed's life work was at Stanford when the catastrophic fire in 1936 took his lab and all its contents--including the most complete marine biological record of West Coast intertidal invertebrate life in existence at the time.

During none of this time was Ed Ricketts known as "Doc"--the name given him in Steinbeck's 1945 fiction. Ed's revolutionary focus on the aggregation and inter-relationship of species--the basis for the Monterey Bay Aquarium (and all modern aquaria)--has been clouded by the lore and myth of an accomplished scientist with a fictional curse. There was no "Doc" Ricketts.

In the spring of 1940, two published authors took a voyage of science and leisure to Baja California's Sea of Cortez. One had just published "Grapes of Wrath," the other "Between Pacific Tides." Both had looked forward to this trip since the mid 1930s--part of Ed Ricketts' plan to chart the entire West Coast for publication of a series of manuals on the Pacific intertidal zones from Baja California to the Queen Charlotte Islands of British Columbia.

The trip was financed by John Steinbeck, organized by Ed Ricketts and conducted on board a Monterey purse seiner skippered by Jugoslavian, Tony Berry. It was a nearly new boat, 76 feet long, 25 feet in the beam, with a 165 HP Atlas diesel. On board were John, his wife Carol, Ed Ricketts, skipper Tony Berry, mechanic Tex Travis, and hands Horace "Sparky" Enea and "Tiny" Coletto. Their adventure is on record in the book resulting from this expedition, "Sea of Cortez," 1941--and it's truncated version containing only the narrative of the trip by John Steinbeck (from Ed Ricketts' log notes) in the "Log From The Sea of Cortez, " 1951--and for some time bearing only John Steinbeck's name. There is absolutely no doubt, however, that it was a through and genuine collaboration by both men. The philosophical and mystical side of Ed Ricketts appears through the material in forms like "non-teleological thinking," attributed by many unknowing critics as the work and thought of John Steinbeck.

The voyage was a scientific success of major proportions but John and Carol fared so badly, as their marriage continued breaking apart, that Carol is unmentioned by Steinbeck in the account of the trip in "The Sea of Cortez." The book was written at Bruce and Jean Ariss' cottage on Lobos Street in the hilly pine woods above Cannery Row as John sat for portraits by Ellwood Graham and his wife, Barbara [Judith Deim]. After Ed's tragic death in 1948, John added the "About Ed Ricketts" to the separated "Log" when published in 1951.

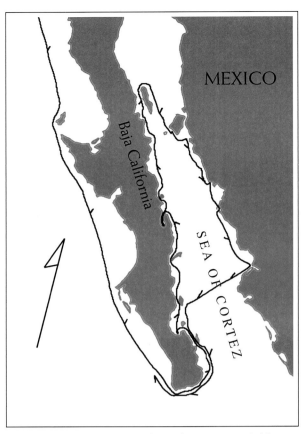

The route of the nearly six week expedition to Baja California's Sea of Cortez from March 11th to April 18th, 1940.

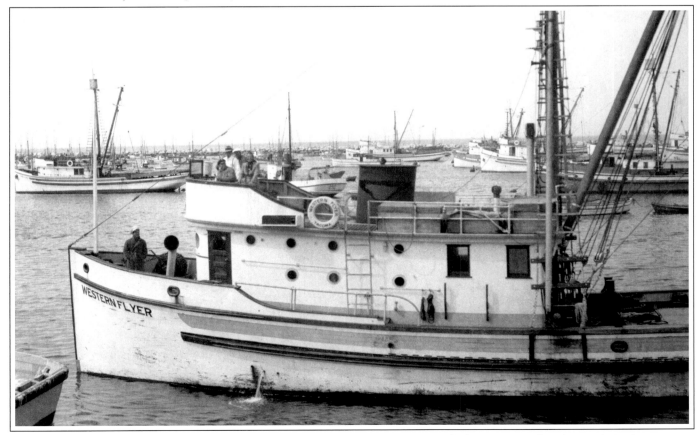

John and Carol Steinbeck on the flying bridge of Skipper Tony Berry's "Western Flyer" in Monterey harbor on its return from the March-April 1940 voyage to the Sea of Crotez.

Fred Strong photo [95-033-008]

On the evening of May 8th, 1948, Ed Ricketts started his old car and drove from the Lab toward town on Ocean View Avenue. Beyond the San Xavier cannery and the Tevis estate houses it turns to climb the hill, to the intersection with Drake and Wave Avenues. Just uphill from the intersection was an unmarked but familiar rail crossing. It was at this fateful spot Ed's car was struck by the evening Del Monte Express train inbound to Pacific Grove. The Oxnard cannery warehouse obscured the track view toward town and the train struck Ed's car before he was able to exit it. It is probable that his car had stalled and Ed tried too long to restart it before trying to get out through the driver's-side door.

The impact of the steam engine crushed Ed between the driver's-side door and the door post, pushing the car several hundred feet down the track before coming to an emergency stop. A crowd of stunned residents and some cannery workers gathered. Police photos show the rider's side door open and Ed lying crumpled in the grass with serious head and internal injuries. Some believe had Ed tried to exit the old car on the rider's side he would likely have survived.

Ed died of his injuries on May 11th, in spite of valiant efforts to save him. John Steinbeck flew immediately from New York, but did not arrive before Ed passed away, days before his birthday on May 14th. John, as a financial partner in Pacific Biological Laboratories, went through Ed's combination office, lab and home at 800 Ocean View Avenue, purging and segregating Ed's records, correspondence and scientific materials. He was assisted by a friend and co-worker of Ed's at Cal-Pac, photographer George Robinson. Together they disposed of materials Steinbeck excluded from distribution to friends and family and materials for Hopkins Marine Station.

The Lab sat vacant for three years after Ed's death, until rented by a Monterey High School teacher, Harlan Watkins, who bought it in 1956 from Jack Yee, the son of Won Yee, the Lee Chong in Steinbeck's "Cannery Row." It was Harlan and his group of friends—who would soon buy the Lab from him to keep as their private men's club—that started the Monterey Jazz Festival. All this as Ocean View Avenue prepared to become, officially, Cannery Row, in January of 1958.

Looking down on the shed behind the Lab in the early fifties, several years after Ed's death.
Harlan Watkins [98-007-001]

This view down the unfinished Irving Avenue from Wave Street shows the boarded up Pacific Biological Laboratories, the concrete warehouse replacement for the Lone Star Cafe of Flora Woods, and a corner of the actual "Palace Flophouse"--the name and location, but not the building Steinbeck described in "Cannery Row."
George Robinson [81-21-0109]

Harlan Watkins provides us a view looking out of the shed in back of the Lab. The shed covered concrete tanks that held biological specimens [98-007-002]

TABLE 8

HISTORICAL REVIEW 1916–1968

TABLE 8
SEASONAL LANDINGS IN TONS
Sardines

Season*	Reduction ships	San Francisco area	Monterey area	Los Angeles area	San Diego area	Total tons
1916–17	----	----	7,710	17,380	2,440	27,530
1917–18	----	70	23,810	41,340	7,360	72,580
1918–19	----	450	35,750	32,530	6,810	75,540
1919–20	----	1,000	43,040	16,580	6,410	67,030
1920–21	----	230	24,960	11,740	1,520	38,450
1921–22	----	80	16,290	19,220	910	36,500
1922–23	----	110	29,210	33,170	2,620	65,110
1923–24	----	190	45,920	35,040	2,780	83,930
1924–25	----	560	67,310	96,330	8,820	173,020
1925–26	----	560	69,010	61,990	5,710	137,270
1926–27	----	3,520	81,860	64,720	2,110	152,210
1927–28	----	16,690	98,020	67,900	4,650	187,260
1928–29	----	13,520	120,290	119,250	1,420	254,480
1929–30	----	21,960	160,050	140,540	2,620	325,170
1930–31	10,960	25,970	109,620	38,490	80	185,120
1931–32	31,040	21,607	69,078	42,656	264	164,645
1932–33	58,790	18,634	89,599	83,605	62	250,690
1933–34	67,820	36,336	152,480	125,047	1,746	383,429
1934–35	112,040	68,477	230,854	178,818	4,865	595,054
1935–36	150,830	76,147	184,470	138,400	10,651	560,498
1936–37	235,610	141,099	206,706	138,115	4,594	726,124
1937–38	67,580	133,718	104,936	109,947	383	416,564
1938–39	43,890	201,200	180,994	146,403	2,800	575,287
1939–40	----	212,453	227,874	96,827	112	537,266
1940–41	----	118,092	165,698	175,592	1,202	460,584
1941–42	----	186,589	250,287	148,912	1,585	587,373
1942–43	----	115,884	184,399	201,510	2,868	504,661
1943–44	----	126,512	213,616	135,311	2,690	478,129
1944–45	----	136,598	237,246	178,294	2,767	554,905
1945–46	----	84,103	145,519	173,110	951	403,683
1946–47	----	2,869	31,391	194,774	4,768	233,802
1947–48	----	94	17,630	101,154	2,463	121,341
1948–49	----	112	47,862	131,830	3,922	183,726
1949–50	----	17,442	131,769	186,433	3,281	338,925
1950–51	----	12,727	33,699	303,752	2,910	353,088
1951–52	----	82	15,897	111,774	1,351	129,104
1952–53	----	----	49	5,635	27	5,711
1953–54	----	----	58	4,111	323	4,492
1954–55	----	----	856	67,099	510	68,465
1955–56	----	----	518	73,943	----	74,461
1956–57	----	----	63	33,564	16	33,643
1957–58	----	----	17	22,255	----	22,272
1958–59	----	----	24,701	79,264	6	103,971
1959–60	----	----	16,109	21,146	1	37,256
1960–61	----	----	2,340	26,436	102	28,878
1961–62	----	----	2,231	23,295	2	25,528
1962–63	----	----	1,211	2,961	----	4,172
1963–64	----	----	1,015	1,895	32	2,942
1964–65	----	----	308	5,717	78	6,103
1965–66	----	----	151	535	33	719
1966–67	----	----	23	311	10	344
1967–68	----	----	10	61	----	71

* Season June through the following May.

Department of Fish and Game, Fish Bulletin No. 149: *The California Marine Fish Catch for 1968 and Historical Review 1916-1968*, by Richard F. G. Heimann and John G. Carlisle, Jr., 1970. A statistical study of disaster.

The publication of Steinbeck's Cannery Row in 1945 coincided with the zenith of Monterey's sardine fishing and canning era, as wartime production enabled its proclamation as "Sardine Capital of the World!" The echos of this proud boast had hardly faded when the Monterey sardine industry and the community it supported were visited by an irony and agony of catastrophic proportions.

The 1945-46 season was nearly *half* of the volume of the previous year's catch. A stunned industry held its breath and awaited the 1946-47 season: it was to be the worst since 1922! And the 1947-48 season was to be, unbelievably, even worse yet! "Table 8" provides an all-too-vivid picture of the rise and fall of an industry predicated upon the impossible.

POST MORTEM

The honest fear that the worst had really happened was settling in on Monterey. No longer an academic argument between businessmen and biologists, the sardine simply wasn't there for the capture. Ed Ricketts' death was somehow almost symbolic of the unexpected, impossible tragedy for which the cannery barons and fishing families of Monterey were totally unprepared.

Angelo Lucido, Sal Ventimiglia, Knut Hovden and the remaining canners desperately attempted trucking iced fish from the Santa Barbara area, and as far south as Port Hueneme. Spoilage, transport costs and insufficient volume doomed such attempts by an industry that had already had its chance to anticipate such contingencies, but had not.

As canneries closed, many into bankruptcy, a ghost town pallor and despair hung heavily over Ocean View Avenue, as strong as the former smell of baking sardine meal. It was going and would soon be gone, this street of the sardine.

The Bear Flag was now a concrete warehouse; the La Ida Cafe all but closed, its sign reading "Rooms For Rent." The Wing Chong Market was soon to be liquidated by Won Yee's son, Jack. The filming of the RKO movie "Clash By Night," a production by Louella Parsons' daughter Harriet, could scarcely find enough fish for filming the documentary-like opening scenes of a coastal fishing and canning community. This classic film starred Barbara Stanwyck and introduced Marilyn Monroe, in her co-starring debut — as a cannery worker on the cutting machines! — in an industry in its last futile gasps.

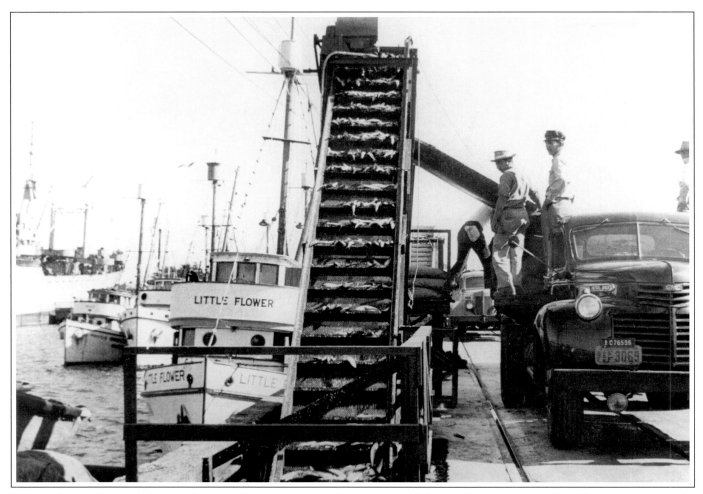

While sardine supplies were holding out further south, desperate canners began trucking fish from southern ports, such as Port Hueneme, to Monterey for processing. Spoilage, low volume, and high transportation costs doomed the efforts. [74-12-13]

TRUCKIN'

On this count, little can be said that this photo of one of the Hovden trucks being unloaded on Ocean View Avenue doesn't implicity say: less than a lampara lighter of sardines, hundreds of miles by road from fresh capture further south, sluiced into a proud cannery accustomed to dozens of boatloads loads larger than this per day. The obviously futile effort to keep Monterey canning by this method of delivery to the sardine factories of Cannery Row was a cruel and ignominious punishment for the industry's ignorance, greed and arrogance. Of all the photographs in this book, this one is perhaps the most poignant because it illustrates the futility of not having managed a potentially unlimited resource intelligently, upon which the entire industry and its dependents predicated their survival. Trucking fish was doomed to failure.

The Hovden cannery a decade earlier in its heady heyday.　　　[76-06-02]

Absolute disaster had become absolute reality as the true cost of continued operation of canneries suddenly located hundreds of miles from its source of fish became apparent.　　　*Fred Harbick photo* [73-06-049]

The RKO crew and a crowd of Monterey spectators watch the night-time filming of the closing scenes of "Clash By Night" at Wharf #2. Barbara Stanwyck and Robert Ryan are on the purse seiner; Harriet Parsons, Hollywood's first female producer, is the lone woman amoung the men on the left of this photo.
Donn Clickard [81-041-027]

Harriet Parsons, daughter of Hearst Newspaper columnist Louella Parsons, produced a film in Monterey in mid-October, 1951, for RKO Pictures. Harriet was the first female producer in Hollywood and worked for mogul Howard Hughes. The film, "Clash By Night, " starred Barbara Stanwyck, Robert Ryan, Paul Douglas, Keith Andes, and--in her first dramatic co-starring role--Marilyn Monroe.

The opening scenes of the film is a documentary style sequence of a fishing port with a fleet of boats going out to sea under dark skies, the setting of nets and hauling of silver fish into holds, and the unloading of fish at the canneries of an anonymous fishing town. This documentary-like opening followed the path of the silver fish into the cannery, to the cutting lines, where rows of women at cutting machines placed the fish in "slots" (see page 72) for cutting prior to packing. One of them is Marilyn Monroe in her first co-starring scene, on the slots at the San Xavier cannery. Hollywood contributed a valuable look at the fishing and canning process in setting the opening scenes of this motion picture. Filming the fishing and canning sequences, however, was anything but easy in the 1951 season.

An industry accustomed to 200,000 tons of fish per season was experiencing a season destined to end with less than 16,000 tons. In her unpublished autobiography, Harriet Parsons bemoans the problems of having a fleet and a railroad at her disposal, but no fish for the scenes in the script. It was with great effort, and not a little cunning, that so few fish she and director Fritz Lang did finally obtain from the stricken fleet were made to look so plentiful as to belie the real scarcity of fish from in silver tide for which Monterey had become so internationally famous.

Some of the filming, however, became entertaining in its own right, when an enterprising canny worker, Jesse ("Tuto") Paredes, intentionally sent a can down the can chute sideways at the Oxnard cannery packing line, causing the line to be shut down--so all the cannery workers could rush to the windows to see Marilyn Monroe being filmed in a scene being shot on the street outside.

The legacy of RKO's 1952 black and white film "Clash By Night" is a celluloid record of the real-life skippers, fishermen, cannery workers and residents of Monterey's dying fishing and canning industry. Its scenes of Fisherman's Wharf and Cannery Row remain today as a lasting and accessible glimpse at Monterey as a working fishing port with its world-famous street at the heart of a tough industrial district that would all too soon simply die on its waterfront.

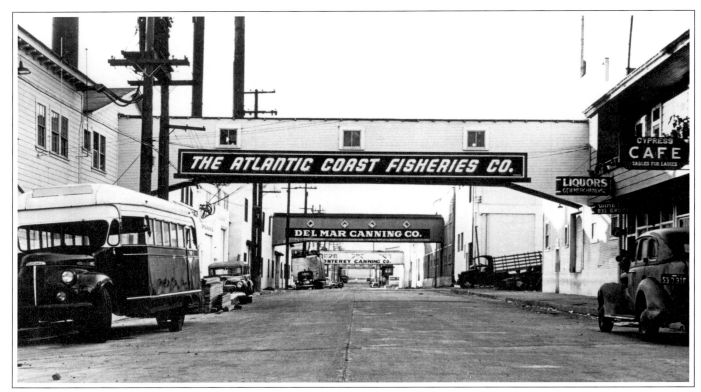

Ocean View Avenue looked like this at the end of each season. Unthinkably, the last season would come too soon. Fred W. Harbick [73-06-02]

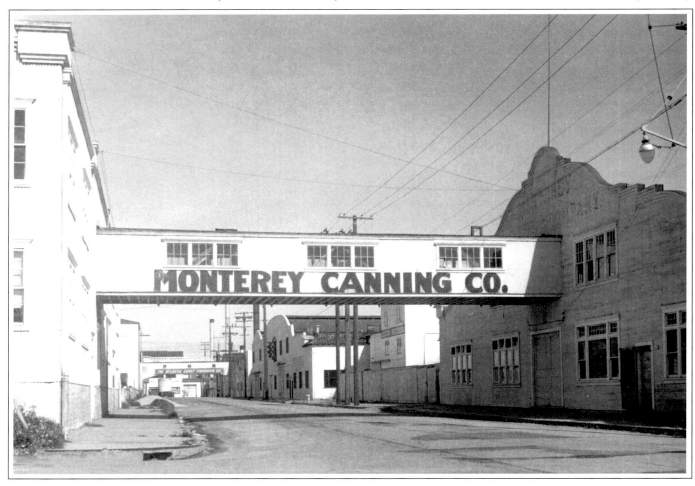

Words fail the obvious. *George Robinson photo* [79-109-01]

The plague of fire was to visit Cannery Row, claiming huge portions of this once indomitable street. Canneries and warehouses, reduction plants and sardine oil storage — an industry soaked in the oily breath of a zillion sardines and caked with the talcum-fine incendiary dust of its fish-meal dependent indulgence — fell easy prey to both arsonist and accident. The Sun Gate-West Harbor fire at the former Del Mar Cannery in December 1951 began the fire drill on Ocean View Avenue that would last well into the sixties.

As fate would have it, the once stately Ocean View Hotel of Mr. and Mrs. Wu--a symbol of Cannery Row's Chinese origins--was to bear silent witness to the funeral pyre of Monterey's once mighty sardine industry, and the dark and unspoken obituary to its blind and suicidal momentum and arrogance.

Its obituary may well have read: Farewell to the Old Row, buried by ledgers. Its legacy lies in the mosaic of memories borne by its Alumni.

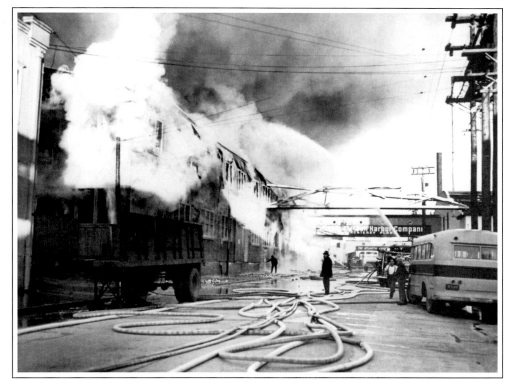

The Sun Gate-West Harbor fire at the former Del Mar Cannery was reported to be the largest food industry fire in the country's history at the time, with an estimated loss of one and a half million dollars.
William Morgan photo [78-34-7]

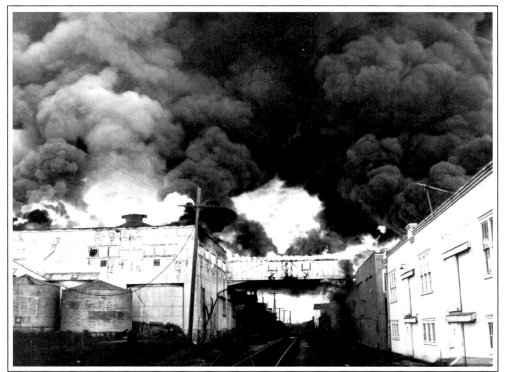

The Sun Gate-West Harbor fire started the fire drill on Cannery Row that would last into its rebirth. The Del Monte Express train was held in Monterey because of the imminent danger of the cross-over collapse about to happen in this William Morgan photo. [78-34-9]

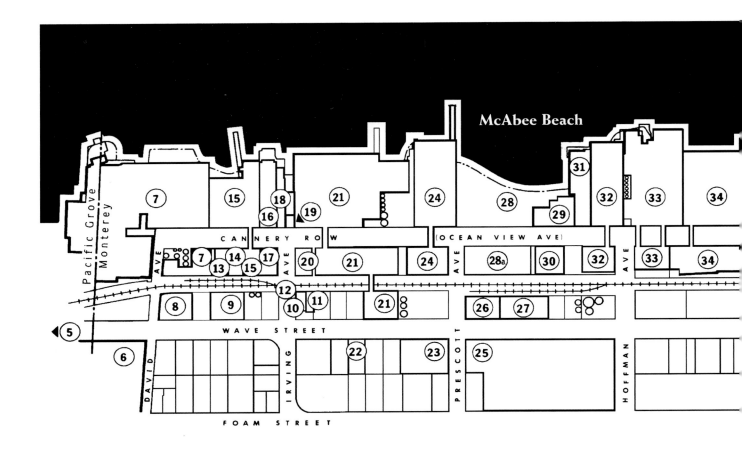

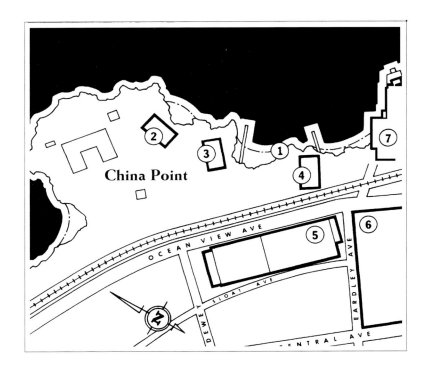

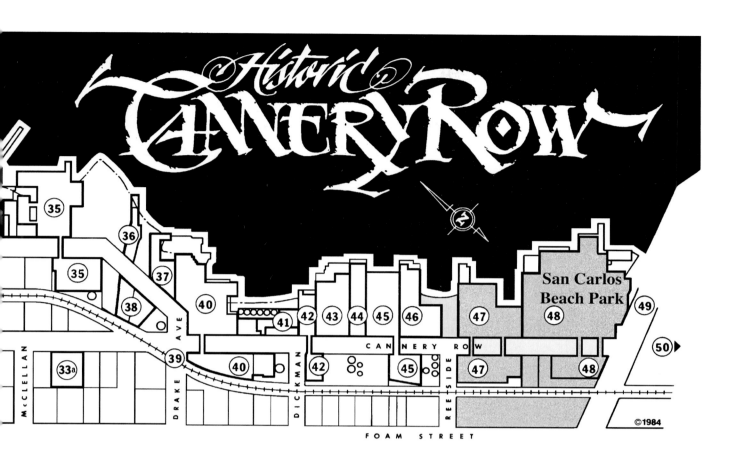

Historic Cannery Row

San Carlos Beach Park

CANNERY ROW

McCLELLAN

DRAKE AVE

DICKMAN

REESIDE

FOAM STREET

©1984

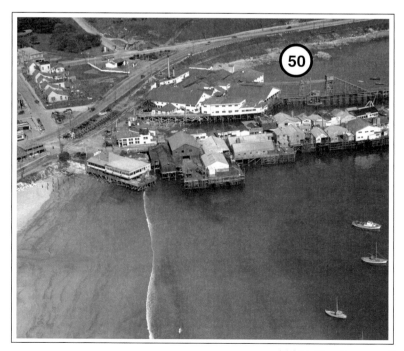

Ted McKay [83-06-05]

Old Row Map Index

1. .CHINATOWN. 1853-1906. Burned May 6, 1906. Many Chinese move to McAbee Beach and establish another, smaller Chinatown, 1907-1924.

2. HOPKINS MARINE STATION. Originally the Hopkins Seaside Laboratory, located at Lovers Point, Pacific Grove. Moved to China Point in 1918.

3. MONTEREY BOAT WORKS. Established by Pearson and Cochran in 1915. Bought out by Gus Smith circa 1919. Bought by Siino Boat Works in 1937.

4. SIINO BOAT WORKS, 1928-1937. Consolidated with Monterey Boat Works in 1937.

5. AMERICAN CAN COMPANY. 1927. Its first manager, Donald E. McDonald, claimed its first year production would be 65,000,000 cans. Closed in 1954.

6. T A WORK LUMBERYARD. Established in the early years of cannery construction.

7. HOVDEN FOOD PRODUCTS CORP. 1916-1973. Norwegian-born canning innovator Knut Hovden, left F.E. BOOTH to open his own cannery on New Monterey's Ocean View Avenue. Burns August 11, 1921 and was rebuilt. Reduction plant blaze October 5, 1924 lasts two days. "The King of Cannery Row" retired in 1951. Site of the Monterey Bay Aquarium.

8. McFADDEN'S, now known as the "OLD COAST HOUSE." A canning era home and boarding house.

9. FISH MEAL BARN above the tracks, behind the WING CHONG MARKET—the model for John Steinbeck's "Palace Flophouse" in *Cannery Row*. (See lower photo, page 103.)

10. "PALACE FLOPHOUSE" in its actual location as a triplex for single cannery workers, sharing a small lot with the CHINESE JOSS HOUSE. *Cannery Row*, Chapters 1 and 7.

11. CHINESE JOSS HOUSE. Burned on this site in March of 1942, damaging the adjacent "Palace Flophouse."

12. "CHICKEN WALK" in *Cannery Row*. Planks up the embankment from the tracks to the unfinished Irving Avenue.

13. LA IDA CAFE. 1929. One of the Row's "houses of ill repute." *Cannery Row*. Chapter 7.

14. WING CHONG MARKET. Won Yee and eleven Chinese Investors open a grocery and drygoods store, September 1918. *Cannery Row*, Chapter 1.

15. The Japanese owned GREAT WESTERN SARDINE CO. (1917) becomes SEA PRIDE PACKING CO. in 1925. Sells to Stewart and Irving in 1929, becoming ATLANTIC COAST FISHERIES in December 1945. Cannery burns in 1980.

16. MONTEREY FISH PRODUCTS. Established in 1915 by "reduction" pioneer, Max M. Schaefer.

17. "VACANT LOT" and BLACK CYPRESS of *Cannery Row*. Introduction and Chapter 1. Location of MALLOY'S BOILER, Chapter 8.

18. DEL VISTA PACKING CO. 1946. A late entry into the reduction business, owned by the Yee family.

19. PACIFIC BIOLOGICAL LABORATORIES. 1929. Edward F. Ricketts moved his biological supply business from Pacific Grove. Appears as "Western Biological Laboratory" in *Cannery Row*, Chapters 5, 10, 20, 21 and 30. A private men's club since 1957.

20. FLORA WOOD'S LONE STAR CAFE. 1923-1941. The "Bear Flag Restaurant" of "Dora Flood"— the Row's most notorious bordello and its most magnanimous madam— Chapters 3 and 16 of *Cannery Row*. Flora dies in apparent poverty living on Alvarado street on August 1, 1948.

21. BAYSIDE FISH AND FLOUR CO. 1916. Became Cypress Canning Company, September, 1927. Became DEL MAR CANNING CO. on January 26, 1928. A major fire on November 25, 1936 also destroys Ed Ricketts' Lab. Both are rebuilt. Burns as SUN GATE-WEST HARBOR on December 8, 1951.

22. MOW WO'S. A Chinese grocery and hardware store established in the early 1920's.

23. AURORA HALL. An early 1920's YMCA, Portuguese Hall, boxing ring and cannery worker's cafeteria.

24. MONTEREY CANNING CO. 1918. Constructed on the site of the Chinese "Monterey Fish Canning Co." (1910-1916) by Scotsmen George Harper, and A. M. Allan— partner in the Point Lobos abalone cannery.

25. UNION SUPPLY COMPANY. Lumber mill and yard owned by Henry Hansen. Now a muni cipal parking lot.

26. F. E. BOOTH REDUCTION PLANT. Construction begins October 2, 1917 as Booth's late entry into large-scale fish meal and fertilizer production. It could not be located with his cannery in the harbor.

27. EDGEWATER PACKING CO. Added to the World War I era F. E. Booth brick reduction plant, circa 1940.

28. McABEE BEACH. An early Portuguese shore-whaling station from the 1860s, named for the Scot whose beach cottages and boat rental replaced whaling from this beach near the turn of the century. Many Chinese relocated to this site, leased to them by McAbee after the fire at China Point in 1906.

29. OCEAN VIEW HOTEL. 1927-1983. Built and owned by Mr. and Mrs. Maen Chang Wu on part of the McABEE BEACH CHINATOWN site (1907-1924).

30. MARINA APARTMENTS. 1929. An annex to the Ocean View Hotel built by the Wu's. It became an "institution of commercialized love."

31. SEA BEACH PACKING CO. Groundbreaking in September, 1945. Bums in 1953.

32. CUSTOM HOUSE PACKING CORP. 1929-1952. Closes in November 1952. Burns in October 1953.

33. CARMEL CANNING CO. 1918-1962. Ben Senderman retires, selling his new cannery to local investors. It burns in 1967.

34. MONTEREY FISHING AND CANNING CO. 1902. Harry Malpas and Otosaburo Noda build the first cannery on the New Monterey coastline. It becomes PACIFIC FISH CO. in August, 1908—the first major canning operation on what was to become Cannery Row. It was bought by CALIFORNIA PACKING CORP. on March 1, 1926. Closes in April, 1962. Burns in 1967 and 1973.

35. SAN XAVIER CANNING CO. 1917. Frank Raiter's "San X" cannery burns in 1967. Its reduction plant remains.

36. WESTERN SARDINE CO. Construction begins on this reduction plant in December, 1945.

37. THE FERRANTE CO. Built by Sal Ferrante, son-in-law of Pietro Ferrante, in 1945.

38. Early addresses of Ben Senderman and the Hovdens. Constructed as support houses for the TEVIS ESTATE near the turn of the century.

39. SITE OF ED "DOC" RICKETTS' COLLISION with the evening Del Monte Express, May 8, 1948. Born May 14, 1897; he dies May 11,1948. Steinbeck details the tragedy as part of "About Ed Ricketts," the preface to The Log From the Sea of Cortez. 1951.

40. OXNARD CANNING CO. Sal Ferrante builds this huge cannery in five months, opening in October, 1942.

36-44. TEVIS-MURRAY ESTATE. 1901-1944. Hugh Tevis died on his honeymoon; the palatial estate built for his bride sold to James A. Murray in 1904. The estate occupied nearly 1,000 feet of Monterey's scenic coastline (sites 36 through 44). Sold in late 1940s to become canneries and reduction plants.

41. WESTERN FISH PROCESSORS. July 1943. A "stick-water" (waste water) treatment plant that reduced liquid canning waste into concentrated by-products--accompanied by Monterey's famous horrendous odor.

42. AENEAS SARDINE PACKING CO. 1945. Its cannery-to-warehouse "cross-over" is one of only two originals left on The Row. Like many late entries to the industry, it was to be the victim of poor timing.

43. CENTRAL PACKING CO. A reduction plant constructed on the Tevis Estate site.

44. RONADA FISHERIES and MAGNOLIA PACKING CO. Late 1940s entries into the reduction process.

45. ENTERPRISE PACKERS. The warehouse building remains of this cannery, constructed in 1945 during World War II demand and just proceeding the disappearance of the sardines.

46. CALIFORNIA FISHERIES CO. 1916. A Japanese export firm destroyed by the oil tank fire of September, 1924. Sal Ventimiglia builds CALIFORNIA FROZEN FISH CO. on the vacant site in 1945.

47. E. B. GROSS CANNING CO. 1919-1943. Destroyed by the 1924 oil tank fire and rebuilt. Ed Gross sells in 1943 to PENINSULA PACKING CO.

48. SAN CARLOS CANNING CO. 1927. Angelo Lucido headed this major cannery that was owned by boat owners and fishermen. It burns on Thanksgiving, 1956.

49. COALINGA OIL AND TRANSPORTATION PIER. 1904. Also known as the Associated Oil Company Pier, this 650-foot pier was destroyed by the oil fire of 1924 at storage tanks for the terminus of a pipeline from Coalinga. Monterey's BREAKWATER was constructed on its location. 1934.

50. F. E. BOOTH CO. 1903-1941. In 1903, Booth buys out his competitor H. R. Bobbin's rudimentary plant and expands it into the first major canning operation of Monterey's sardine era. "The Father of the Sardine-Industry" is forced out of business in 1941 by fellow cannery owners who help ensure that his municipal lease in the harbor is not renewed. He closes May 28,1941. He dies December 12, 1941.

When the once 12 inch Monterey sardine was fished until the adults were the size above, the end was well in sight.

IN THIS APPENDIX

INDEX

END

BIBLIOGRAPHY AND RECOMMENDED READING

Astro, Richard. *John Steinbeck and Edward Ricketts: The Shaping of a Novelist.* Minneapolis: University of Minnesota Press, 1973. Republished by Western Flyer Publishing, 2002.

Benson, Jackson J. *The True Adventures of John Steinbeck, Writer.* New York: Viking Press, 1984.

Cutino, Peter T. *Monterey, A View From Garlic Hill.* Pacific Grove: Boxwood Press, 1995.

Elstob, Winston. *Chinatown. A Legend of Old Cannery Row.* Berkeley: Condor's Sky Press, 1965.

Enea, Sparky, as told to Audry Lynch. *With Steinbeck in the Sea of Cortez. Memoirs of the Steinbeck/ Ricketts Expedition.* Sand River Press, 1991.

Hedgepeth, Joel, ed. *The Outer Shores.* (Two volumes). Eureka: Mad River Press, 1978.

Hemp, Michael K. *CANNERY ROW, The History of Old Ocean View Avenue.* Carmel: The History Company, 1986. (First Edition).

Larsen, Stephen and Robin. *A Fire inthe Mind, The Life of Joseph Campbell.* Doubleday, 1991.

Larsh, Ed B. *Doc's Lab: Myths & Legends of Cannery Row.* Monterey: PBL Press, 1995.

Lydon, Sandy. *Chinese Gold: The Chinese in the Monterey Bay Region.* Capitola: Capitola Book Company, 1985.

Lydon, Sandy. *The Japanese in the Monterey Bay Region. A Brief History.* Capitola Book Company, 1997.

Lynch, Audrey. *Steinbeck Remembered.* Fithian Press, 2000.

Mangelsdorf, Tom. *A History of Steinbeck's Cannery Row.* Santa Cruz: Western Tanager Press, 1986.

McGlynn, Betty Hoag. *"Casa de Las Olas"* (House of the Waves; the Tevis Murray Estate). *Noticias del Puerto de Monterey* (Quarterly bulletin of the Monterey History and Art Association).

Reinstedt, Randy. *Where Have All the Sardines Gone?* Carmel: Ghost Town Publications, 1978.

Rogers, Katharine A. *Renaissance Man of Cannery Row, The Life and Letters of Edward F. Ricketts.* University of Alabama Press, 2002.

Steinbeck, John. *Cannery Row.* (Paperback) with introduction by Professor Susan Shillinglaw. Penguin Edition, 1994.

Thomas, Tim. *The J. B. Phillips Historical Fisheries Report* (Series). Monterey Maritime Museum, 2000-2001.

Weber, Tom. *Cannery Row, A Time to Remember.* Orenda/Unity Press. 1983.

Yamada, David T. *The Japanese of the Monterey Peninsula, Their History & Legacy.* Monterey Peninsula Japanese American Citizens League, 1995.

BY JOHN STEINBECK

Cannery Row. New York: Viking Press, 1945.
Log From the Sea of Cortez. (Containing the preface "About Ed Ricketts") New York Viking Press, 1951
Sweet Thursday (The sequel to *Cannery Row*) New York: Viking Press, 1954.

BY EDWARD F. RICKETTS AND JACK CALVIN
Between Pacific Tides. Stanford University Press, 1939.

SOME VALUABLE INTERNET WEB SITES

The Intenet has become a wealth of easily accessible information on Cannery Row, the Monterey fishing and canning industry, Ed Ricketts and modern ocean conservation, and the world fame of Nobel and Pulitze author, John Steinbeck.

The History Company maintains links to a select number of the growing and changing variety of sites relating to Cannery Row, providing updated resources, research materials, photos and other items of Cannery Row interest. The following web sites are also suggested as key starting points for your particular interest in the subjects in this history of Old Ocean View Avenue.

Feel free to submit links to The History Company for sites you discover in your internet searches that you feel could be helpful to others interested in the topics related to this history of Cannery Row. We will be happy to share them with others also interested in knowing more about old Ocean View Avenue and its colorful history.

www.thehistorycompany.com
Monterey, California's historic resource for information, reference, research, links and collectible Cannery Row items. Historic research, consulting, presentations, publications, and links to Cannery Row related history, conservation, collections and resource sites for John Steinbeck and Ed Ricketts.

www.canneryrow.org
The non-profit Cannery Row Foundation, dedicated to the acqusition and preservation of Cannery Row history and the literary and scientific legacies of John Steinbeck and Ed Ricketts. Sponsor of historic and educational events on Cannery Row, the annual John Steinbeck and Ed Ricketts birthday celebrations, and tour docents of Ed Ricketts' Pacific Biological laboratories on behalf of the City of Monterey. Established in 1983; constructed the Ed Ricketts Memorial at Drake Avenue and Wave Street, Cannery Row. Sponsored the John Seinbeck Centennial bronze bust by Jesse Corsaut, on display at the City of Monterey.

www.caviews.com
Archival photo collection, open to the public, with over 80,000 historic images of California (hence the name "California Views"), owned and operated by photo archivist Pat Hathaway. The collection can be viewed in person in albums of photography from which prints can be ordered in sizes from 8 x 10 to murals. Image listings at this site provide access to photos of historic Cannery Row, Carmel, Pacific Grove, Pebble Beach, Carmel Valley, Point Lobos, Big Sur, Salinas, the San Francisco earthquake and fire, and all of the California Missions.

www.steinbeck.org
The web site for the National Steinbeck Center, Old Town Salinas, California--the center of the John Steinbeck world. This non-profit public museum and Steinbeck resource center exhibits Steinbeck books and literary themes in interactive exhibits focused on celebrating the genius of John Steinbeck. This major museum produces a full calendar of educational and cultural events and special activities based on Steinbeck literary themes and is a major archive for Steinbeck research.

www.sardineking.com
Sardine King: The largest collection of vintage California sardine can labels in existence, available through the internet. Created by Los Angeles based packaging designer, James Bridges, sardineking.com specializes in old Cannery Row, Monterey, California sardine can labels from the 1920-1940s. There you can find photo galleries of old California sardine, pilchard, mackerel, squid and tuna can labels from the old canneries and fishing fleets of Monterey, San Francisco, Oakland, Oxnard and Los Angeles. These images can be downloaded without charge, a feature designed to make this collection available for school classes and educational uses. Collectors of sardine can labels--or if you are interested in becoming one--are invited to contact sardineking.com about available labels you wish to acquire. These full-color labels are an artistic record of the Monterey sardine industry.

A label from www.sardineking.com

The Ricketts family: Ed Jr., Anna, (front) Cornelia, Nancy, and Ed at the Carmel home of Eds' brother-in-law, Fred Strong. [99-016-08]

Ed at Mt. Franklin, Texas, 1918. *Ed Ricketts* [99-029-01] *Ed in Carmel by brother-in-law Fred Strong* [95-033-02]

Ed's mother, Alice B. Ricketts, with Ed and his son, Ed. Jr.

Fred Strong photo 1936 [95-033-03]

Cal-Pac Plant 106, 1928--the chemistry lab where Ed Ricketts worked in the waning years of the industry. His son, Ed Jr., workd at the main plant 101. [87-01-02]

Tech Sgt. Ed Ricketts, 1943, with Tony's daughter, Kay. Fred Strong photo [99-026-003]

Tony Jackson with Ed Ricketts circa 1943 in a photo by Ed's brother-in-law, Fred Strong. [99-026-0027]

EDWARD F. RICKETTS (May 14, 1897 - May 11,1948)

Fred Strong photo, circa 1936 [95-033-01]

"The Row"

A street with every right
to be dead...
and odds that it should be
were it not for the
Steinbeck in all of it.
An incomplete demise
of a way of life and another time
perhaps better truly dead
than irreverenced...

-- Michael K. Hemp